MMXIII

GO BIG OR

Go Home.

GO BIG
or
GO HOME

KAT VON D

Taking Risks in Life, Love, and Tattooing

with
Sandra Bark

HARPER DESIGN
An Imprint of HarperCollins Publishers

This book is dedicated to

Danny Lohnër

for making me feel like I belong.

 TABLE OF CONTENTS

Introduction

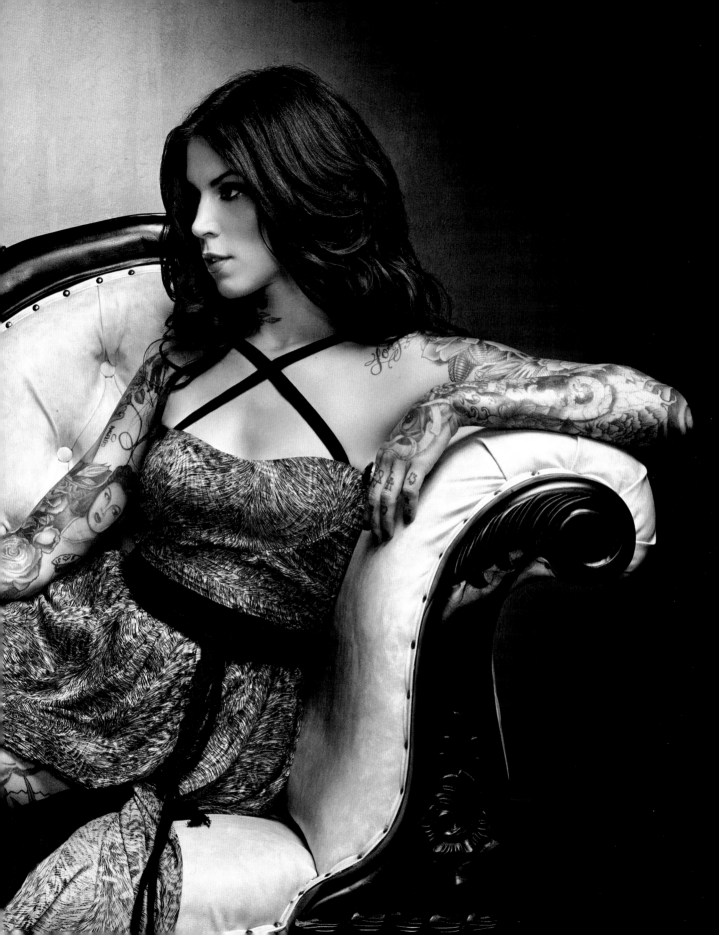

"I can see right through you. You're afraid to let go, and it's stagnating your growth." Linda Perry said that to me—and she was right.

I don't think I've ever wanted something so badly: to be free of all the thoughts and fears that keep me from doing things. Something as simple as opening my mouth and making a sound—that's all I really wanted. I wanted to sing, and not just the tiresome scales I had become so well acquainted with. I could habitually la-la-la my way through the vocal exercises that my voice coach had taught me back when I'd taken up lessons with him three years ago.

I wanted to sing out loud, and in front of anybody and everybody. And it wasn't because I was bored or because I had something to prove, but because something inside me demanded that of me. I hate to blame it on some "universal calling," but I struggle to find any other way to describe it. Wanting to sing was like the urge I felt in my early teens to pick up a tattoo machine—there wasn't a hint of intent behind the doing. The doing just was.

I didn't feel the need to question the path to tattooing; I only knew I wanted to move in that direction, so I kept going. Tattooing felt like home—it felt natural. Of course, I was aware that you can't pick up something like tattooing overnight. Becoming a tattooer would require learning and practice, and in no way was I planning on taking any shortcuts. But none of that mattered, as long as I could keep my eye on my goal. Regardless of the number of challenging obstacles that might stand in the way, I wasn't afraid to risk everything for what I knew to be my calling.

That was just how I felt about it.

So I approached learning to sing in the same way. Starting from scratch, I learned about how to use my voice as an instrument. I tried to get rid of long-held ideas I had about it, too, like what I thought it could and couldn't do, or even how it did what it did. Every step was filled with a little bit of excitement and a whole lot of uncertainty, and I just aimed

> **Regardless of the number of challenging obstacles that might stand in my way, I wasn't afraid to risk everything for what I knew to be my calling.**

toward the light. With every hour of practice—discouraged at times by my slow progress but encouraged to never give up by my voice coach—I moved closer to feeling more comfortable with my voice.

And then something happened. Not just in my singing but in everything. I felt afraid. Fear, the dark and cruel monster that resides in my mind, no longer lay quietly dormant.

Consumed by the feeling, I was no longer in control of my life. I let fear monopolize my thoughts. I let it take over and drown me in my own self-created nightmare of self-doubt and self-criticism. I became reclusive.

I do understand why this happened to me, or how I allowed it to happen. Or maybe that's just my ego making an excuse for the self-conscious person I've become. This last year broke me in ways I tried so hard not to admit to myself or to others.

I found myself wounded with the sting of failure because of risks I'd taken that hadn't really worked out

so well. Placing all bets on a relationship—as if I were betting on a horse and knew that the outcome of the race would be triumphant—left me vulnerable to a merciless reality when the relationship didn't turn out to be what I believed it would be. I'm not just referring to love here, but to work relationships, friendships, family ties—all my relationships to the people I had held so close to my heart.

The aftermath of those defeats killed my spirit in a lot of ways. I became terrified of trying new things. Where I'd once shared with the world what I was doing with conviction and strength, I was now suddenly contracting, holding back with all my might, recoiling in fear.

It's not like I never imagined the world unanimously chanting "I told you so" or "You're going to fail again" when I took a risk or didn't succeed, but those voices were never the problem. The true culprit was my own voice in my own head: I allowed that voice to convince me that those things were

I chose to focus on larger pieces in this book because for many of my clients, these tattoos are powerful symbols of their commitments to feed their souls and their spirits.

true. Sure, maybe I lost fans due to the hype in trash tabloids, and sure, some people formulated opinions based on gossip. But it doesn't always take tabloid hype or the judgments of people who have never met you—yet who criticize you nonetheless—to feed the fear.

Most of the time, the fear of failure is instilled in childhood. There were always plenty of folks who told me time and time again that I wouldn't amount to anything; that tattooing was a dead-end street; and, furthermore, that pursuing art as a career was a childish, unrealistic fantasy.

I never believed them. And thank the stars I didn't! Because if I had, who knows what I'd be doing today? Who knows what mundane job I would have settled for instead of pursuing my art? I was strong enough to stick to my guns back then, regardless of the outcome.

I want to feel that way again. I want to be free like that again. Yet somehow it feels impossible not to beat myself

up when I feel like I've caved. And that reminds me of another memorable thing Linda once said to me: "There's so much strength in vulnerability. It's the ultimate gift you can give yourself because you allow yourself to open up; to invite someone in."

She knows me better than most people, and, once again, she was right. Maybe the fear of vulnerability comes from never feeling good enough growing up. Maybe I saw vulnerability as a form of weakness and withdrawing as a way to protect myself. It's easier to create the illusion that I am unaffected and don't care what others think about me than to admit defeat or feeling vulnerable. In reality, sometimes I just hurt.

The rants I'm sharing aren't meant as a way of venting or of pleading my case. Allowing myself the freedom to share is just another way to practice letting go of the thoughts and feelings that hold me back. Ideally, I hope my words speak to people to make those who feel lonely in similar struggles feel less alienated and alone than I have in the past, and, ultimately, to

help them in some way. I'd be lying if I said I've remedied all of the loose screws in my head. Far from it—but at least I can see a way out.

This book is not about my singing or how to overcome stage fright. It's not a memoir made up of stories to win anyone over, or to serve as a pity party I'm throwing for myself.

Whether large or small, tattoos can have equally profound significance and backstories. I chose to focus on larger pieces in this book because for many of my clients, these tattoos are powerful symbols of their commitments to feed their souls and their spirits. They're a reminder that a true self lives deep inside each of us. That self is asking to be set free so it can nurture us—if only we will take a risk and let it. You don't have to get a huge tattoo to be free, of course. Hell, you don't even have to have a single one to experience a taste of freedom either, so read on.

This book—as well as the tattoos and stories behind them—is about the gift of freedom, and I want to share that gift with you.

2002

only knew his music, and I loved it on first listen.
It was dark and it was beautiful. It was metal
and it was poetry. It was love loaded into a gun,
and I wondered about the man behind the songs.

Two years later, our paths crossed, and like a majority
of the connections I've made in life, tattooing brought
us together. Through our first tattoo sessions, we began
to get to know each other. For the next few years,
I just thought of him as my friend from overseas,
and that was all. Then, after knowing him for six years, something
changed. It could have been the wine, the music, or the moon.
Most likely it was just perfect timing. Just one kiss, and he changed
my world.

We were both sad back then, and lost. I was depressed, having
finally ended a marriage that had been doomed from the beginning.
I was also dealing with the pressures of filming a television show,
which was totally new to me—and drinking my way blindly through
it all. His story mirrored mine, and he had been feeling just as low.

We each had been waiting for something to happen, for someone or
something to come along and save us from ourselves. And when
it suddenly seemed that that someone was each other, it took us both by
surprise. We shared darkness, and doing that brought light back into
our somber worlds: for once, we didn't feel alone.

5

10

15

20

25

"I am not eccentric. It's just that I am more alive than most people. I am an unpopular electric eel set in a pond of catfish."

—Edith Sitwell, LIFE magazine, January 4, 1963

Individuality has nothing to do with surface appearance, although it can be expressed externally, and the external inevitably influences how people first perceive you. But true individuality is more about being in tune with who you truly are, whether you're expressing yourself physically, mentally, or spiritually; individuality arises from living without fear of what others might think or say about you and without being swayed by their opinions, leaving you free to lead life without caring about judgments made by the outside world.

For as long as I can remember, I have always felt different in my own way. From when I was pretty young, I felt a sense of alienation from the rest of the world, and that feeling made it so easy to feel disconnected from other people. But eventually I realized that individuality is not about being alone; it's about embracing the characteristics that distinguish you from others, while still maintaining a sense of connection to the universe to which we all belong. Where you come from, what you look like, and what your past holds do not define

you as an individual—you are what you make yourself to be. Yet we all experience joy, sadness, loss, fear, hope, and anxiety, so in a sense we are ultimately all the same. Practicing this way of thinking made it so much easier for me to see the world with compassion, patience, and love, instead of with criticism, judgment, and fear of things I might not understand. This way of thinking was something I picked up on through various books I'd been reading, and I tried to practice it each day.

In my early teens, I shaved the sides of my head into a thick Wendy O. Williams—inspired mohawk. My haircut was a shock to my folks, and as much as I never intended on scaring them, their unwillingness to understand where these forms of self-expression were coming from made it hard for us as a family.

We all experience joy, sadness, loss, fear, hope, and anxiety, so in a sense we are ultimately all the same.

Most people in the suburban town where we lived assumed I was rebelling or that there were problems back at home. Some even jumped to numerous assorted conclusions: either I was a drug addict, or I was uneducated, or I had low self-esteem.

None of those things were true. To me, the haircut represented beauty and strength, that I was a woman who would live her life without the boundaries imposed upon her by other people.

Honestly, I wasn't trying to be insubordinate. I wasn't trying to prove anything. I just felt compelled to profess my love for beauty and individuality in a way that most people around me found disturbing—especially on a girl. But my point of view was that the mohawk was a way to filter out close-minded people. The way I saw it, if a person couldn't see past what they

Who are your heroes? Why do you look up to them? Why do we respect those who live and think for themselves as opposed to doing what is expected? We all admire the idea of living a life unbound by thoughts of fear.

considered to be a ridiculous hairdo to connect with the real me, then I didn't want to be around them anyway.

The truth was, I just liked the way the haircut looked and felt. As shocking as it was to some, my hairstyle was never meant for anyone but me. After all, I was the one who had to look at myself in the mirror. I was the one who had to like or dislike what was reflected back.

Nowadays, I've caught myself trying to get back to the mind-set I had back when I was less concerned about the judgments of others. I'm not necessarily interested in shaving my head again because if there's one thing I've learned, it's that material goods and external appearances are trivial matters.

What's truly important—and what I find myself forgetting and having to relearn—is that right here, right now, I am free. Free to be myself and to express myself.

Your true self knows nothing else other than its freedom to be whatever you believe it to be. If I consciously make the decision to listen to music, not because it's forced on me by advertisers and the media, then I listen to music because I choose to. Because I like it. If I choose to be a tattooer, even if the entire world lines up to tell me that tattooing isn't going to take me anywhere, then I am free. I have made a

conscious decision to do something I love and that makes me happy, regardless of the outcome, regardless of how much money I'll make, regardless of whether others take me seriously. Then I have made up my individual mind.

Nothing physical can ever define our true natures because our true individual selves are far too vast to be limited to that. Our uniqueness is already there. It's just waiting for us to realize it and exercise it.

Who are your heroes? Why do you look up to them? Why do we respect those who live and think for themselves as opposed to doing what is expected? We all admire the idea of living a life unbound by thoughts of fear. People who seem to live that dream inspire us to want to do the same. They mirror the qualities that we possess but are too scared to access.

One time, after beating myself up emotionally during one of our vocal training sessions, my vocal coach Ken asked me, "Why do you think people like Kat Von D?"

I was too deep in wallowing in self-pity to offer a logical answer.

"In the end, what people love about Kat Von D," he said, "is that she's real."

Real is the bottom-line characteristic of true individuality. Ken's words sank in, and I cried. I cried not because I didn't believe what

Ken had said to me, but because I realized how far I had strayed from the fourteen-year-old Mohican who was in love with life, in love with art, and in love with being submersed in the freedom of being who I really was. Vulnerable. Passionate. Imperfect. Real. And fearless.

How do I get back to that girl? My ego wants to feel as if I am distinct from other people—and for the wrong reasons. Acceptance doesn't come from being defined by other people. It's quite the opposite. The need to feel accepted, or seek approval from others, whether it's parents, peers, or most importantly, yourself, is inescapable, but the trick is to move past it. Acknowledging that nothing and no one can define you except you—and acting on that knowledge is the marker of the individual.

I am an individual because I am free.

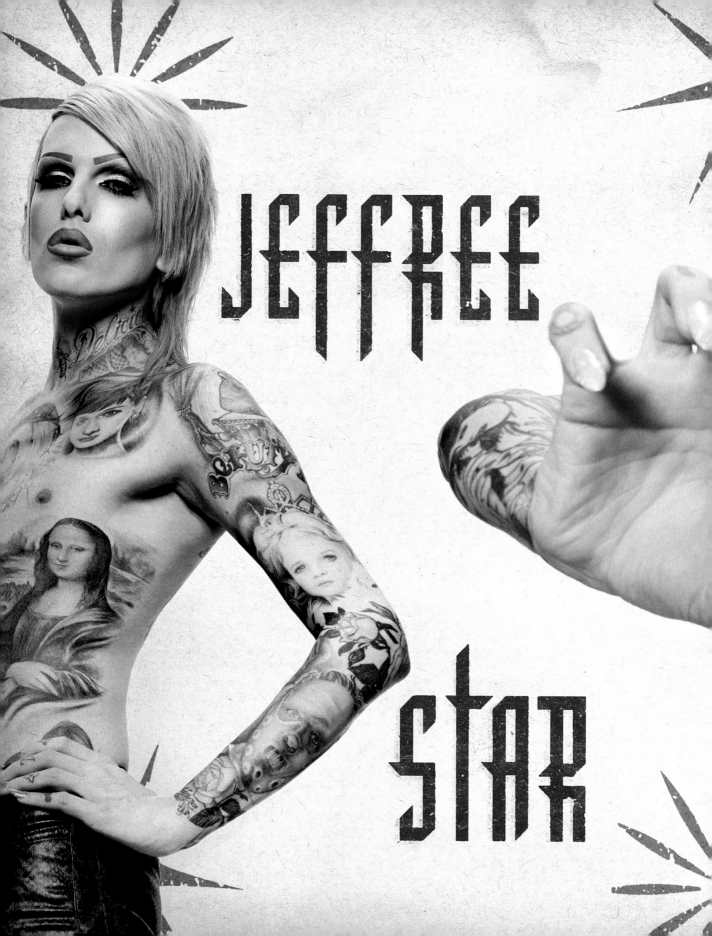

JEFFREE

STAR

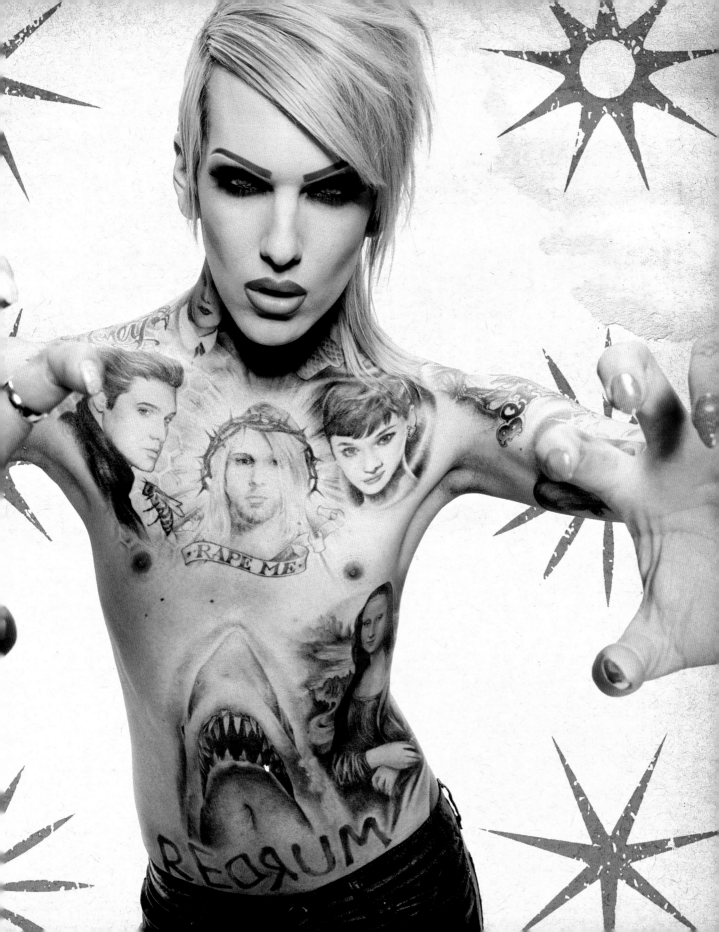

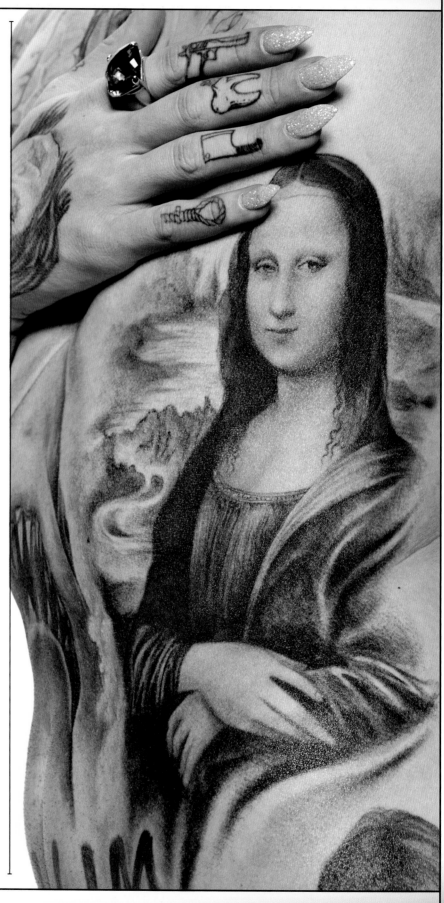

OH, JEFFREE! Where do I even begin?

When I first began tattooing Jeffree almost a decade ago, all I knew was that he was on a mission to be covered fully eventually. He never left a tattoo session without making an appointment for his next one. In the beginning, I didn't quite understand the direction he was going with the overall theme of his tattoos.

With the exception of his Spice Girls back piece and a few other tattoos, the subjects of Jeffree's obsession seemed to lean toward portraits of tragic icons. Some people were shocked or repelled by the tattoos, and even I questioned the reasoning behind some of Jeffree's choices, like his portraits of JonBenét Ramsey, Princess Diana, Sharon Tate, and Elizabeth Short (the Black Dahlia). But session after session, tattoo after tattoo, we spent hours together, which made it impossible not to become close with him. As I began to understand Jeffree as an individual, I understood where his inspiration came from.

Jeffree isn't afraid of the things most people find perturbing. In fact, embracing and seeing them as life lessons as opposed to curses are his gift.

In terms of Jeffree's physical appearance, there's no denying that he stands out, that his appearance doesn't subscribe to the norm. Personally, I adore Jeffree's distinctive sense of style. Knowing about his background helps me embrace his look and his whole way of being much more easily than those who don't know him. From a very early age, Jeffree always felt different in his own way. I think being picked on and even bullied at times for being gay or for dressing differently is a big part of why he's been so outward with his self-expression: his loud hair styles, extreme makeup, and even all the tattoos he's collected quickly over these past few years.

There is something liberating about embracing your own uniqueness,

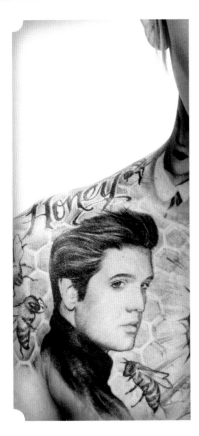

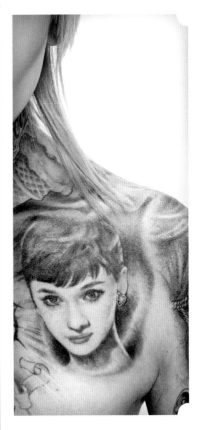

especially when the majority of people around you look down on it. But it's not necessarily about rebelling or seeking negative attention: it's about fully embracing who you are, and maybe even amplifying it. I love that about Jeffree, and I love that his tattoo collection is a massive, profound representation of who he is, his values, and the way he sees the world.

I can't help but wonder at times if these tattoos somewhat reflect his own experiences. Feeling like an outsider is something Jeffree has become all too familiar with, and sticking to his guns from an early age, in a world that's less accepting than it should be, must affect the way Jeffree sees things. I know it does.

Truth be told, I was a little stunned when he decided to fill his entire left rib cage with a classic rendition of Da Vinci's *Mona Lisa*. Only a few weeks before, we had completed an enormous shark tattoo on his abdomen, the famous image from *Jaws*.

Doing these two tattoos was such a contrast—to go from something so graphic to this soft, subdued portrait. But when you step back and look at Jeffree, that is exactly what he is: a balance of extremes—beautiful, controversial, artful, groundbreaking, and inspiring in his conviction.

It's funny, because when I do a classic painting, the tattoo process forever changes the way I see the artwork.

Closely inspecting each and every detail and transferring those details to the tattoo will do that. With the *Mona Lisa*, everything from the winding roads and subtle hills of the landscape to the intricacy of the embellished collar line and the tiny tendrils of curls that frame her neck and chest are almost always what my eyes are now first drawn to—as opposed to immediately focusing on Mona Lisa herself and her gaze. ✛

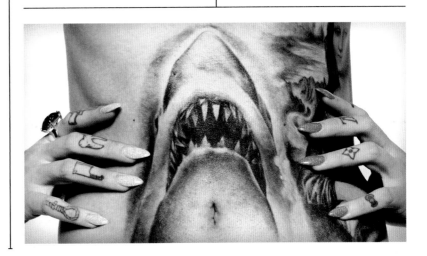

could come and be inspired through art. A place that would inspire people to create art themselves. A place that would allow me to share the gift of art that is the driving force behind almost everything I do.

I thought about creating an art gallery, but I wasn't sure about going in that direction. I'd had a few experiences in the past with high-end galleries, and I never seemed to be able to identify with them. Most of the time, the spaces felt cold and sterile to me—and I felt out of place.

So I made a list of things I love about art galleries and things I dislike about them. I wanted to showcase original work by artists from around the world—the recognized as well as the undiscovered. I wanted to support individual talents that I already knew, like Kevin Llewellyn. I wanted a gallery that

exhibits; I wanted everybody to be as inspired a I was.

The way I saw it, this could very well becom a driving force for art in West Hollywood, an nothing thrilled me more than the idea of bring ing art to the place I live.

Of course, coming up with ideas is often a who lot easier than executing them. But to me, the cha lenge of creating, whether a tattoo or a full-blow business, excites me. It's another opportunity fo me to pour myself into something I believe in an to share it with the world.

Some of my friends didn't get my vision, an I understood where their concerns came fror I knew the chances of the gallery, which is no called Wonderland, ever bringing in an impre

world doesn't necessarily set. Looking at the painting, you can feel how Kevin saw right through the rebellious façade—the loud makeup, neon hair dye, plastic surgery, and the full body armor of tattoos—to the essence of a young boy who's more scared at times than he lets on. A boy who is capable of hurting, just like you and me.

Kevin shows Jeffree as Dorothy as she was portrayed by Judy Garland in *The Wizard of Oz*. With her pigtails and gingham-checked dress, Dorothy is a classic representation of innocence. She's trying to find her way—she's living in a dream within a dream. Jeffree is no different.

When I look at this piece for any extended amount of time, I am reminded of the many renditions of saints that I have pored over during my tattoo career. Their gazes seem very rarely to meet the viewer's eye, but instead are cast outward and into another place. Just as in these classical art interpretations of scripture, Kevin's intention was never to make Jeffree appear Christlike. Kevin's goal was to show the saintly side of the subject.

Don't get me wrong. Jeffree Star is no saint. But neither are you nor I. But that's not to say we can't have saintly qualities: inspiring those around you by embracing your individuality—the way Jeffree does—is a miracle in itself.

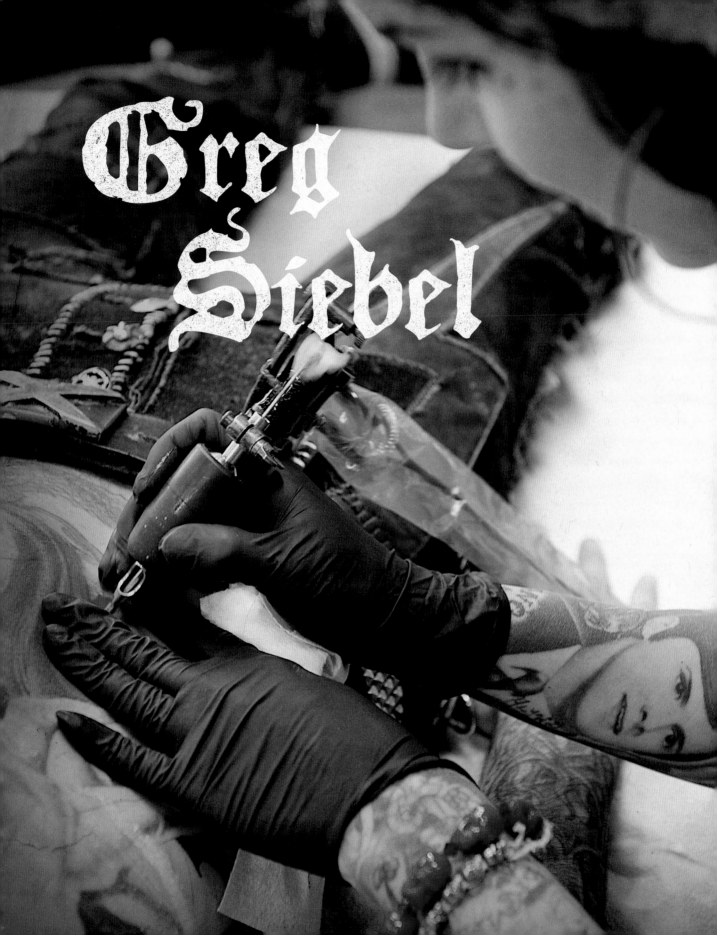

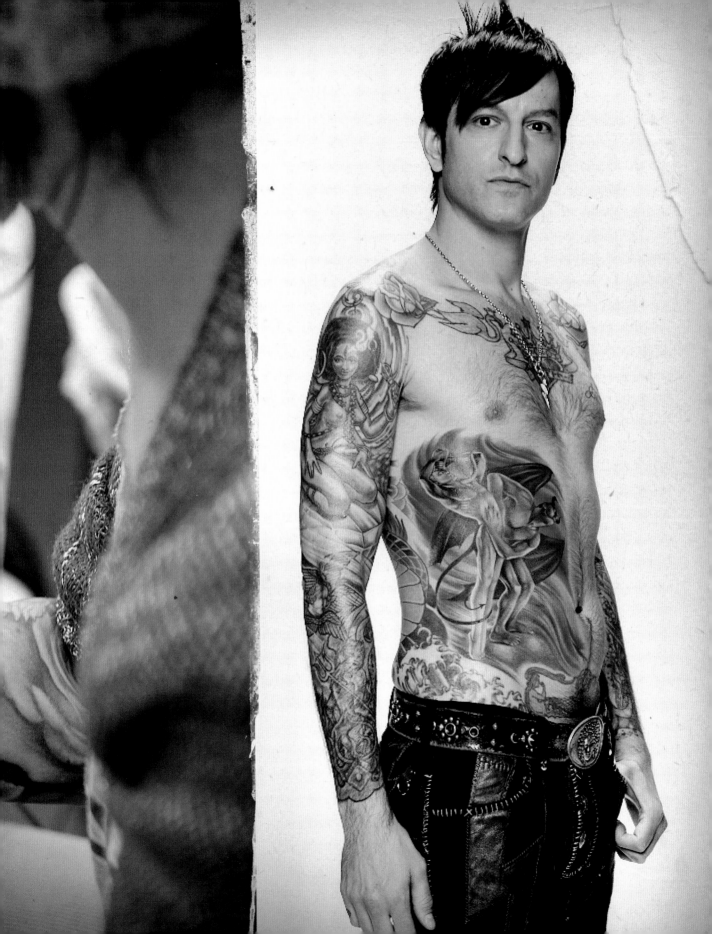

Out of his entire collection of tattoos, this piece, based on a painting by the artist George Quaintance, marks the first time Greg got a tattoo where the art came from an existing work. Usually, he tends to collaborate with the artist tattooing him, providing an idea and letting the tattooer run with it. With this specific piece, I approached the painting as a portrait, replicating its exact details, layout, and color tones so that the tattoo came as close as possible to the original work. I had to make only a few slight adjustments in order for the piece to land perfectly across Greg's entire right side.

The painting alone is pretty compelling, but what I loved about it the most was the way in which it spoke to Greg: for him, it suggests that we are all multifaceted creatures made up of both good and evil, and that to find beauty in all things, even things that frighten you, is liberating. It's the story of his life in a way.

Greg is the head shop manager at High Voltage Tattoo, and after years of working side by side, we are close. We share so much of our daily lives, not to mention talk about everything from love, death, and sobriety to music and fashion.

I've learned that out of all the people Greg's ever looked up to, two women are at the top of the list: his grandmother Molly and Siouxsie Sioux, the lead singer of Siouxsie and the Banshees. On the outside, the two women are so different that you would never guess that they could be equally influential to Greg, but they each represent personal values that mean a great deal to him.

Molly, even in her very last days, was always excited about life and open to learning new things, whether about diet and health, spirituality, or relationships. The more she learned, the more she realized how little she actually knew—and she then wanted to learn more. I've always admired that sort of openness to the world.

In the 1950s, Molly followed a healthy, organic diet, unlike most people at the time, who were eating tons of red meat and processed food. She grew up in a Jewish household, but she looked outside her religion to explore her higher self. She believed in reincarnation, often telling Greg that we all live many lives and keep coming back until we learn the lessons we are meant to. As a kid, Greg never heard anyone in the family except his grandmother speak about reincarnation or channeling spirits, and her beliefs just made sense to him.

Once a month, Molly would attend weekend meditation workshops in upstate New York, where she'd devote her time to lectures, meditating, and hiking. During Greg's late childhood and early teens, Molly would take him along with her, and they'd stay up in her cabin in the Catskills. He cherishes his memories of Molly and credits her for helping him develop his own sense of spirituality.

Besides relating to Siouxsie Sioux's musical talent and lyrics, Greg sees her as the ultimate example of someone who has embraced her individuality. As the leader of the Banshees, she was part of one of the few pioneering British rock bands that shaped music during the post-punk era. Her personal look really deviated from the norm—even in rock 'n' roll—at the time. She has always seemed to do her own thing, not caring how the world reacted to her extreme style or her art. Like Jeffree Star, and like a lot of us, Greg grew up feeling different from the people around him. Instead of suppressing his individuality, he creatively embraced those qualities that made him stand out. He was always modifying his clothes, putting together and wearing outfits that were considered bizarre by those around him. He pursued his interests in the arts—acting, modeling, and fashion—and those interests gave Greg outlets to express himself in a genuine way, helping him to feel comfortable with who he truly is.

I secretly wish I were Greg.

I look up to him in so many ways. In terms of style, he's been such a big influence on me. His passion for music and his knowledge of how it's influenced fashion have taught me so much, especially when I took up designing my own clothing line. And as much as I know he isn't aware of it, I value his opinion highly—more than most people I know. But what I admire most about Greg is that he is so comfortable with who he is now. He's not afraid to share his good energy with others—and people love him for that. Regardless of whether the world says differently, Greg's able to see and be inspired by the beauty in both darkness and light. ☩

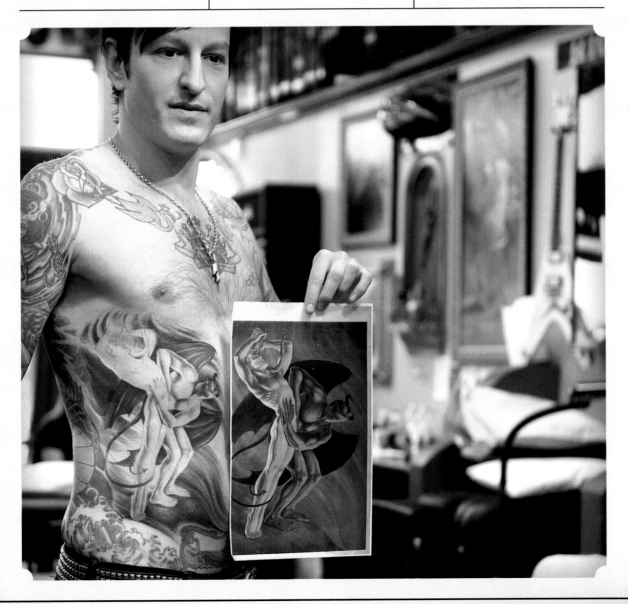

Matt

hether it's through tattoos or the clothes he chooses, Matt thinks of himself as a canvas for wearable art.

When Matt first saw an image of the Brazilian quetzal, he immediately fell in love with the contour of its feathers and the drape of its tail. The bird's shape naturally forms a beautiful silhouette that transfers easily into a tattoo. Always favoring a balance, Matt wanted to get two renditions of the quetzal; one on each thigh. The goal was to make the pair of birds similar in their use of space, but not symmetrical—and this made every tiny detail vital to the final pieces. As small as they are, the white and yellow highlights in the eyes of each bird play a big part in adding a jewel-like sparkle to the tattoo.

Even though Matt is not a tattooer himself, I was a little intimidated by the idea of giving him a tattoo because he has such an excellent eye for detail, texture, and composition. Having worked for Helmut Lang for more than a decade, and having been an avid tattoo collector for about as long, Matt's very fine-tuned to aesthetics.

Matt's choices for the color combinations for each of the birds were beautiful and complemented each other so nicely. His original idea was to have the birds be mirror images—right down to the colors. Then, while he was healing from our first session, he came up with the idea of keeping the general shape and posture of the birds identical, but making the plumage of the second bird different from the first—which is far more interesting. Yet, when they are seen side by side, it's as if one shouldn't exist without the other. ✣

Maurer

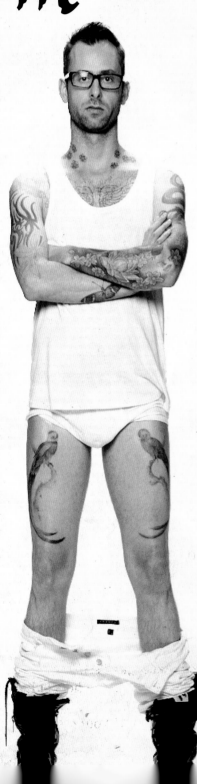

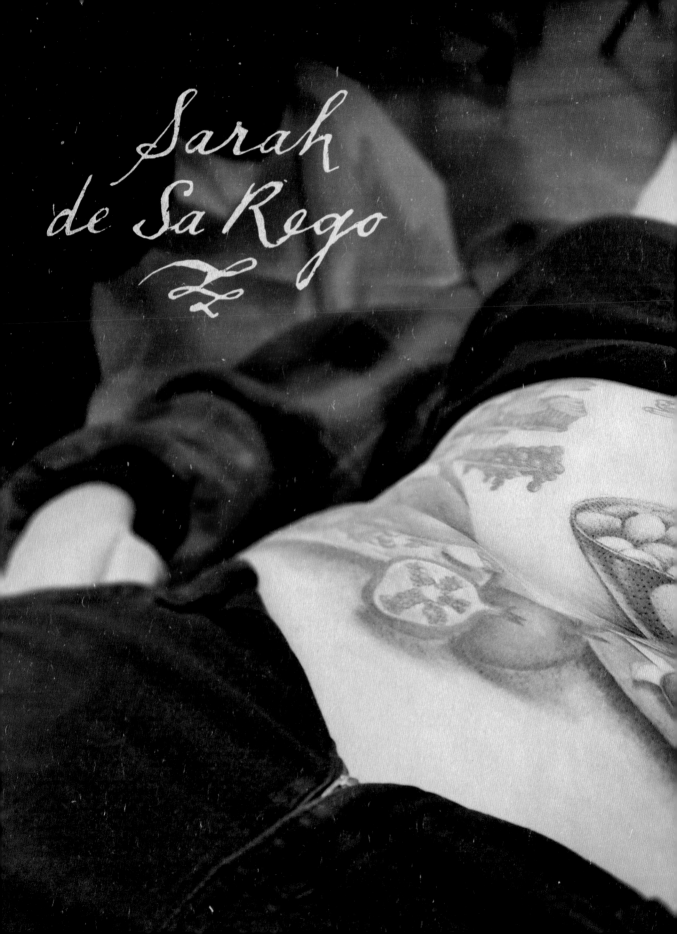

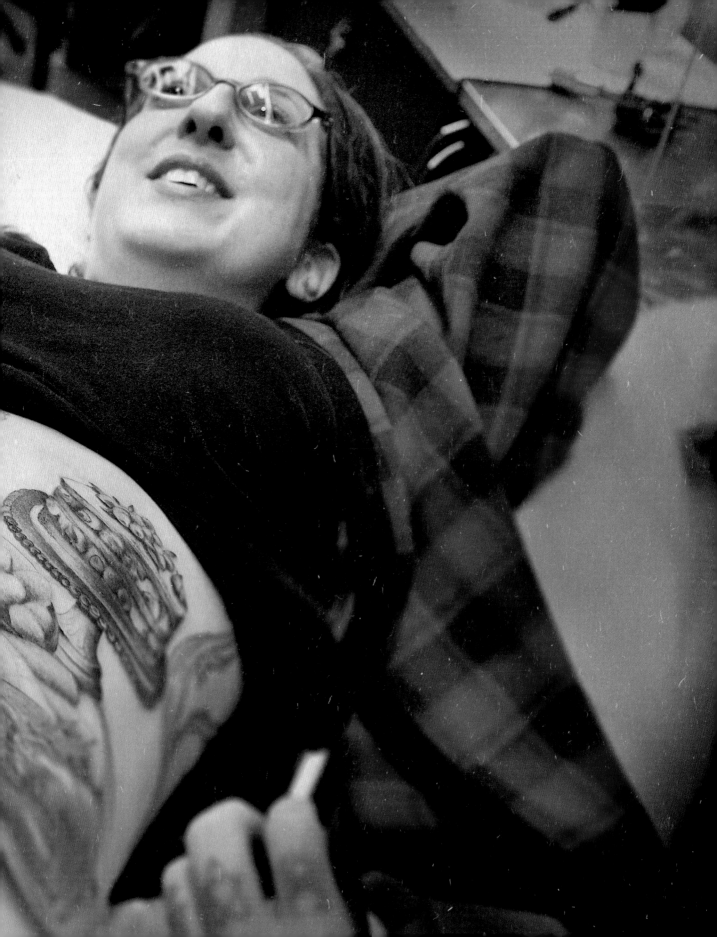

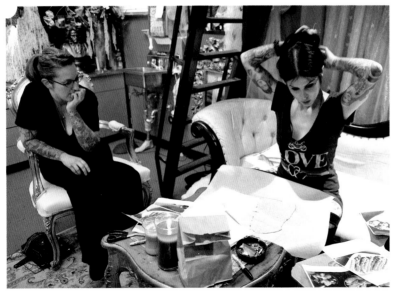

I had the luck of meeting Sarah when she conspired with her husband's daughter, Tasha, to surprise him with a tattoo for his birthday. I was already familiar with Bobcat Goldthwait's history in the world of comedy, so I was prepared for a hilarious tattoo session that day. What I did not expect was to spark a close friendship with his equally if not more hilarious wife, Sarah.

Straightaway, I liked her. She was quick, witty, and above all, smart as hell, with the remarkable ability to make everyone around her laugh. People like Sarah make me wish that I could see the world through their eyes and make the spontaneous connections that light up the humor in situations.

We bonded over fashion. As a costume designer who dresses actors for film and TV, she has an incredible knowledge of clothing history. The more I learn about what she does, the more admiration I have for her. It takes months of work behind the scenes to create a moment on film. An attention to style, story, and continuity is just one of the many things that are part of her work as an experienced costumer.

Sarah is constantly surrounded by society's idea of "beautiful" people— the Hollywood actors and actresses

who often set the standard for what is considered "attractive." But one of my favorite qualities about Sarah is that she doesn't let that standard become her ideal.

When she presented the concept for her own tattoo, I immediately laughed. Perhaps because Sarah and I are usually on the same wavelength, the joke was clear to me. But from what she explained, people she worked with didn't agree as much. When you tell people, "I wanna get a feast tattooed on my belly," they may not take to the joke the same way we did.

I like that Sarah is comfortable with seeing herself, flaws and all, with humor. Her view is that life isn't about taking everything so seriously; that's something I've definitely learned from her. As she said to me, "I never want to mock others, because when you can make fun of yourself [instead], then everyone can have a good time."

One of the trickier parts of the tattoo process was sifting through the stacks of food element ideas and choosing which would work best. The types of foods we ultimately went with weren't necessarily Sarah's favorites, but those that would translate clearly in a tattoo. We both love Mexican food, but nachos and beans wouldn't necessarily make for a good tattoo!

Once we figured out foods that would translate, the next challenge was to compose them in proper proportions on the area of her body where we were going to work. Putting certain pieces in the foreground made it easier to include as many entreés as possible, while neatly placing trays of cupcakes in the far background.

This piece was much more time-consuming than a lot of the others I've done. Color tattoos generally take longer to complete. After three sessions that were each two to three hours long, we were deep into this tattoo, yet we'd only finished a portion—although it was a large portion—of the vision in its entirety. So far, the lobster dish has been my favorite part of the overall tattoo. Using up to three different shades of red and really relying on the high-lighting to give the shell a glossy, almost plastic-like texture was challenging but fun.

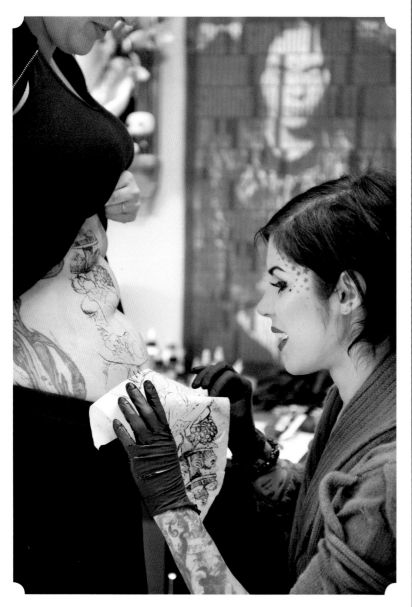

It will be cool to see the additions Sarah chooses to pile on in the future. We've talked about adding more cakes and pastries, brussels sprouts, asparagus, and a few other dishes. This tattoo's been a real challenge—but worth every minute. ✣

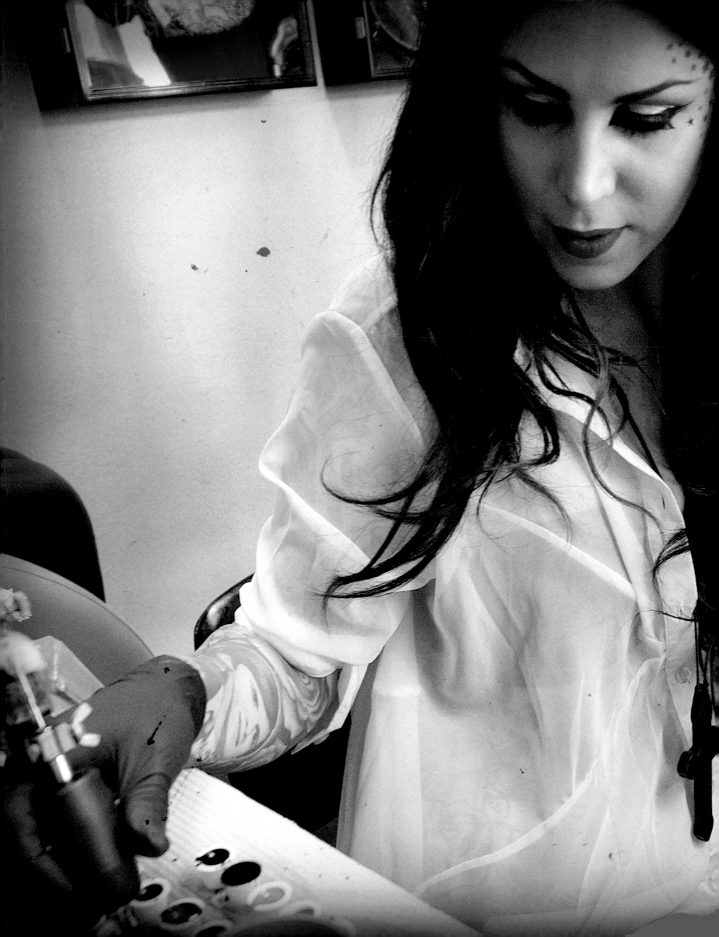

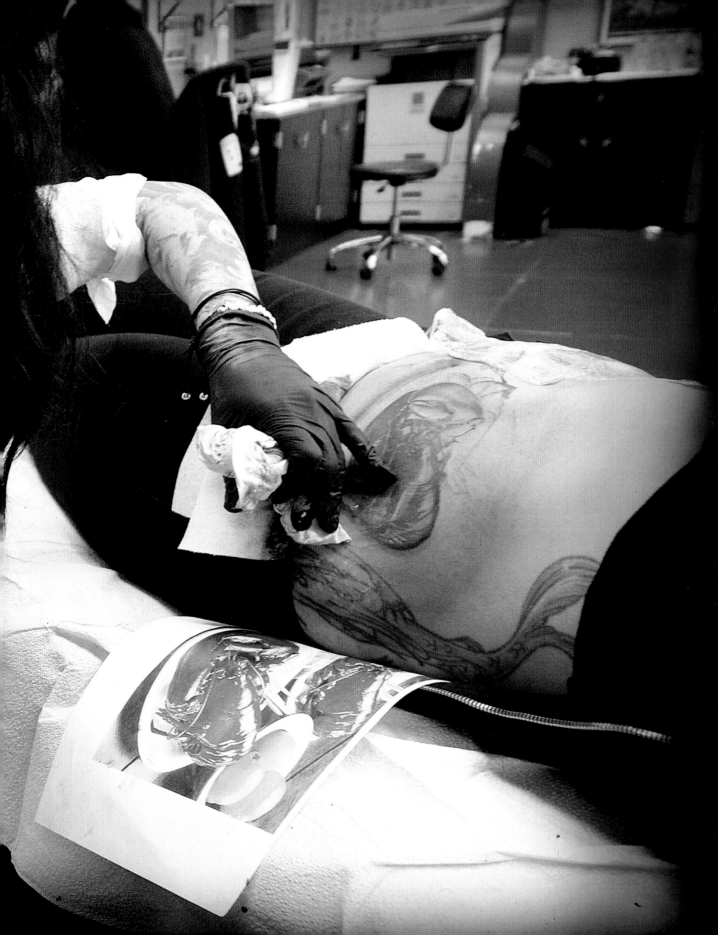

Anyone who spends a measureable amount of time with me will soon discover what a huge Vampira fan I am. Apart from *The Vampira Show*, her 1950s TV program, she was best known for her 1959 cameo role in *Plan 9 from Outer Space*, directed by cult classic filmmaker Ed Wood.

When Bobcat came to me with the idea of having a portrait of Ed tattooed on his arm, I was excited for selfish reasons. The classic black-and-white headshot taken during the height of Ed's career was perfect for tattooing. Bobcat came prepared with quintessential references for the background, complete with images of unsophisticated flying saucers made out of paper plates and suspended by strings from *Plan 9 from Outer Space*.

Although I was familiar with some of the cast members from Ed Wood's films (Béla Lugosi and Vampira), I realized how little I actually knew about Ed himself. But after hours of needling through Bobcat's tattoo, I was happily schooled.

Listening to Bobcat talk about Ed was inspiring, to say the least, because the director had a unique vision that set his work apart from the usual films of his day. Regardless of how badly reviewed the low-budget films he made were, no amount of criticism held him back from achieving a vision. The guy's idea of beauty included imperfection. The notable technical errors, homemade special effects, and trite dialogue eventually gained his films an impressive cult following that far surpasses what most directors achieve today.

Knowing how much Bobcat pours himself into the films and TV programs he directs, many of them pretty offbeat, his respect for Ed Wood makes sense. He said, "I love Ed Wood because his movies are from the heart. They are imaginative and personal. He didn't make them because he wanted to be rich and famous—he made them because he had to, and I respect that." In a world where so many are driven by money, status, and fame, the few with the guts to continue creating, regardless of what everyone else might say about their work, are heroes in my book. ✢

Bobcat Goldthwait

2007

ur timing was the best and the worst. Connecting
romantically during low points in our lives wasn't
a healthy start, but it inspired the much-needed
changes we both had to make.

5

His decision to get sober catapulted my desire to
do the same. In early July, I gave up drinking
and never looked back. Of course, my primary
reason for stopping was for myself, it had to be,
but I won't lie and say he didn't inspire me. Back 10
then, I would have done anything for him. I would
have packed my bags and returned with him to his country never to
return, if he had asked me to.

But he was scheduled to dive back into a worldwide tour with his 15
band. I was contractually bound to Los Angeles by a television show.
Although we had kissed, held hands, painted and drawn each
other, called one another when we needed support, and exchanged love
letters, we never talked about our feelings or tomorrow. In retrospect,
we both had been too scared to say the things that we should have 20
out loud.

I had already started to miss him before we even got to the airport.
His sober eyes were so bright and alive, but the good-bye was
melancholy regardless of the better place we both were in. 25

Too afraid to ask what would become of us, I kept my feelings
to myself, said good-bye, and drove away.

"To be yourself in a world that is constantly trying to make you something else is the greatest accomplishment."

—Ralph Waldo Emerson, THE CONDUCT OF LIFE, 1860

Trying is a form of strength. Being honest about your fears and facing them are forms of strength. Bench-pressing three hundred pounds might give you big muscles, but it doesn't mean that you can look yourself in the mirror and tell yourself the truth.

It can be tough for me, for anyone, to say some things out loud—especially when this means admitting to people that I'm not as strong as some may perceive me to be. So instead of playing "let's pretend" and putting on an attitude of strength like an ill-fitting jacket, I'm going to strip bare and be completely honest, so I can be myself, so I can find my true strength.

I read fan mail, tweets from followers, or comments on Instagram that say things like, "I wish I was as strong as you," or "I admire your strength." I secretly think to myself, "If only you really knew. . . ."

That's when I start to build in my mind what I imagine to be a sense of expectations from others. Of course, those expectations are not real. Understanding the root of much of my dysfunction, and then transcending those habitual instincts to try to please everyone makes it a lot easier for me to have solid relationships, and I've had to work at it. I've put in many hours reading and listening to books and lectures that help me gain

a stronger self-under-standing, that help me help myself. Prompted by my teachers, I thought back to my earliest memories of when these feelings of insecurity began.

Seeking approval from my parents, brother, and sister came first. I carried a deep sense of guilt because I believed that I was the sole reason for my parents splitting up and destroying the family unit we once had. I blamed myself for running away from home at fourteen. But I was in love for the first time and passionate about music and art. I had discovered tattooing.

When my frightened parents forbid practically all of the above, I drew a line. On one side stood my folks and siblings whom I loved, and who I knew loved me, too. On the other side was what I felt was my calling. True love. My art. A greater feeling of being alive.

Perhaps the mistake I made was in believing I had to choose between the two. But I thought I had to choose,

I BLAMED MYSELF FOR RUNNING AWAY FROM HOME AT FOURTEEN. BUT I WAS IN LOVE FOR THE FIRST TIME AND PASSIONATE ABOUT MUSIC AND ART.

and I did. Along with my suitcase, I carried away with me a deep sense of guilt because I thought that it was my selfishness that divided the whole number that was our family into a set of fractions that never again seemed to add up properly.

Life away from my family felt so perfect in some ways, but even though I was free of their demands, I didn't feel free. I felt so guilty. When you love your family the way I did, knowing that my parents were spend-ing nights awake and crying—wondering where I was, whether I was hurt, or healthy, or even alive—was a nightmare for me. Then I would imagine how my brother and sister felt. Abandoned, maybe. Resentful, most likely. I had left them to endure the fallout.

This type of guilt is so heavy to carry, no matter how old you are. For me, it eventually mani-fested itself into seeking approval from the world, especially once I put myself out into the public eye by

appearing on a televi-
sion show.

Some people said I
was a great role model;
others said I was the
worst role model imag-
inable. Some people said
I was fat, but when I
got into shape they said
I'd gone "Hollywood."
Either I didn't tattoo
enough or it was all I
ever did or talked about.
I was an enviable roman-
tic or a total failure at
relationships. I had cool
style, or I was on the
worst-dressed list.

I can't win. I really
can't, and neither can
anyone else. I can't win
and that's totally okay.

It took me more than
a decade to make peace
with the past. Those
experiences no longer
bring me pain because
I've let them go. They
don't define me the way
I used to allow them
to. I've made amends
with my family, and
equally as important,
with myself.

My strength emerged
when I asked myself
what I was trying to
prove, and to whom,
and why. I realized that

I CAN'T WIN. I REALLY CAN'T, AND NEITHER CAN ANYONE ELSE. I CAN'T WIN AND THAT'S TOTALLY OKAY.

the drama I had created
in my mind, associ-
ated with the past, had
blinded me from the
truth. The reality is that
my dad did love me
then, and he does love
me now. He was proud
of me then, and he is
still proud now. I don't
need to overcompen-
sate to please my family
or everyone else around
me. The reality is that
I know I am a good
person, and as selfish as
some of my choices may
have been, my inten-
tions were never to hurt
anyone.

Now that I'm older,
I realize that I couldn't
have been solely
responsible for my
parents' divorce. We
always have our part
in relationships, but
that's exactly it—we
can only account for
our own part. The
issues my parents had
in their marriage were
their issues, not mine.
If my actions magni-
fied existing problems
between them, so be
it, but I finally realized
it would be foolish to
continue condemning

myself for something that just wasn't really my fault.

Forgiving myself and making amends with my family were breakthroughs for me. Big ones.

Strength doesn't necessarily come from resisting fear, weakness, or any other feeling and overcoming it. Strength comes from looking at those things straight on—and accepting them as they really are.

Challenging situations are spiritually better for you than easy ones. They build character and help you grow. If you're open to them, challenges can become life's greatest teachers.

Strength is not about never crying, and it's definitely not about putting on a face in order to protect what's truly going on inside. Being strong is about surrendering to the moment and accepting it; if you can deal with a situation openly and honestly, you can open the door to peace.

I've learned that instead of seeing myself as a weak person for bringing awareness to a few of my many faults, it's very important for me to recognize that I have strength in my ability to see those faults, and change them, if I so please.

We are the masters of our reality. ✣

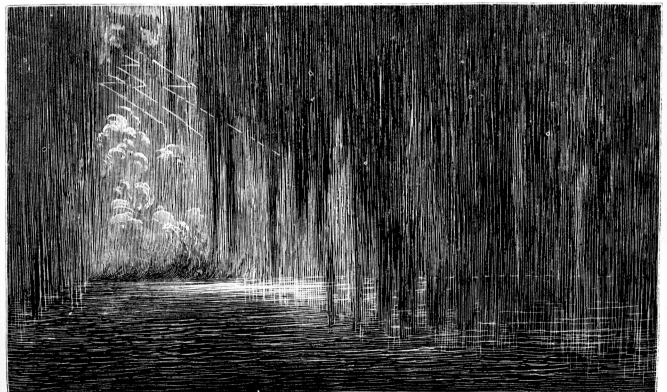

Fig. 1. The Primeval Storm.

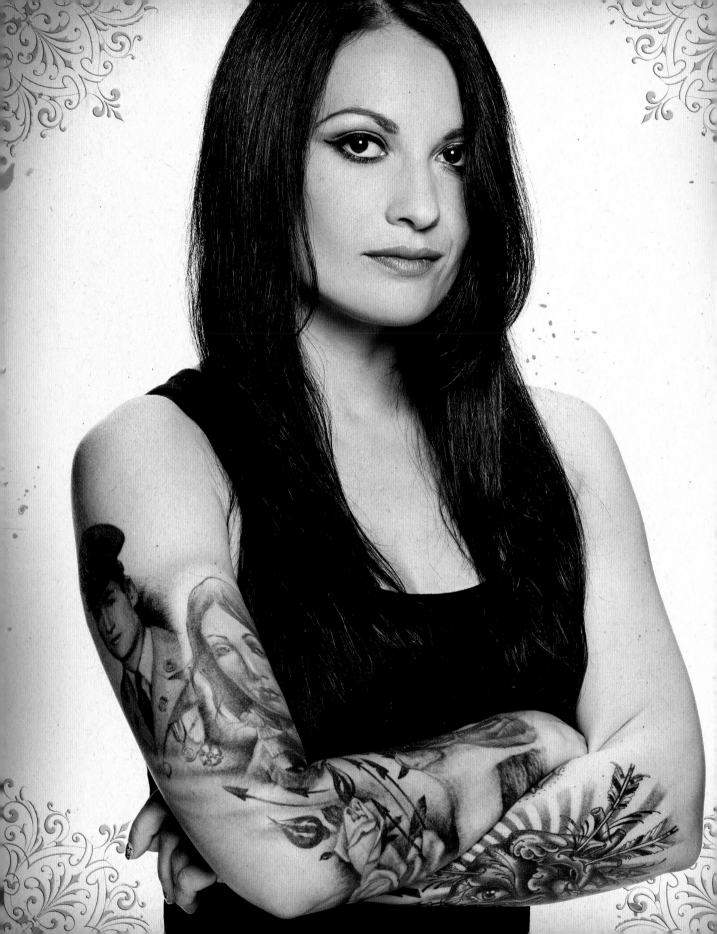

Marya Gullo

efore coming to live in Los Angeles, Marya was my go-to New York friend who shared my sober lifestyle. Sober since 2007, I can still easily be around people who are drinking, but whenever I was in New York City, I'd always opt for going to the tea house with Marya rather than partying.

You could only imagine how elated I was when she told me she was moving out here to Hollywood!

Marya and I were introduced on a photo shoot that she was art-directing. I had a sense that we were connected in some unexplainable way, and it wasn't long after that she reached out to inquire about getting a tattoo. As with many of the friends I have made through tattooing, Marya and I spent our first session getting to know each other.

The portrait of Sacajawea on Marya's arm was an introduction into her life, and it brought us together. The rest of the work I've done on her arm is almost a timeline of the growth

of our friendship. Marya chose Sacajawea because she was a distant relative of her grandfather, Vincent Charbonneau. As much as this sleeve was an homage to her history and ancestors, the tattoo of Sacajawea was a significant cap to all of the Native American, Western, and World War II elements that made up the artwork on her right arm because Marya's grandfather, a World War II veteran who passed away in 2004, still plays a big role in her life.

Losing her grandfather inspired an awakening within Marya at the time she needed it the most. Her grandfather was someone she had always looked up to. He was a source of inspiration and represented so much of what Marya wanted to be like—with his honest way of living and positive attitude. Finally recognizing how much pain she would cause her grandfather if he knew about her self-destructive lifestyle and addiction—and if he could see her during this time, which she considered her low point—helped turn her life around. His passing gave her the strength to make changes, and if that was what it took, then that was an instance when death served as a positive.

I know what it feels like to let down those around you because of the weakness of addiction. But I also know how it feels to take your power back, not for anyone else, but for yourself. And those moments are brilliant. They give you strength.

I was glad to be able to share this tattoo experience with my friend. I've spent so many times talking late at night with Marya, times when it felt like there was no one else to turn to. Sometimes just listening to her struggles and difficulties was enough to help me be a better person, and vice

versa. I have far too many blurry memories of what life was like as a drunk, back before I decided to become sober. I wasn't a good friend, a good daughter, a good wife or girlfriend, and at times it's hard to come to terms with my struggles in the past. But whenever I share with Marya, because she herself has been through a lot of these same situations, her ability to listen never comes with judgment, and her perspective on living in sobriety inspires me. Addiction is addiction, and I don't believe that comparing your experiences with another person's makes your struggles any less challenging, but there are definite levels of extremity, especially when you cross the line into drugs. Marya, who has struggled with some of the most dangerous of addictions, some far more life-threatening than my drinking was, is an inspiration to me. If she can stay sober, so can I. This tattoo was a gift to Marya, but it was also a gift to myself, a reminder to stay as strong as she. ✛

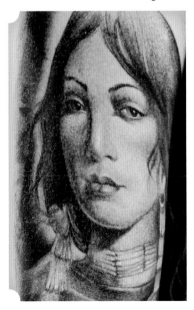

Ayesha King

"To me, what makes a strong woman is her complete devotion to who she is on the inside."

— AYESHA KING

During the Baroque era, at a time when women painters were not readily accepted by the artistic community or patrons of the arts, the accomplished Italian painter Artemisia Gentileschi was highly revered. Artemisia was the first female painter to become a member of the Accademia delle Arti del Disegno in Florence. Many of her paintings featured strong, suffering figures from mythology or biblical stories, and it was her best-known painting that Ayesha wanted to have tattooed: *Judith Beheading Holofernes.*

The story of Judith comes from biblical times. Although her story never made it into the Bible proper, it seeped into the public consciousness and has inspired artists throughout the centuries. Influential painters such as Caravaggio, Rembrandt, Peter Paul Rubens, and Eglon van der Neer all derived inspiration from the story of Judith, channeling it into great works of art. Renditions of Judith beheading Holofernes are abundant, but it wasn't until the 1600s that renderings of this scene done in a far more brutal, violent manner began to surface.

Artemisia's version is even more interesting in light of the fact that she was a rape victim who prosecuted her

attacker successfully at a time when female assertiveness was highly uncommon. *Judith Beheading Holofernes* is almost a self-portrait, with Judith representing Artemisia, and her rapist, Agostino Tassi, as Holofernes. For many years, the story of Artemisia's rape, and the fact that she was a successful female painter in a time when that was unheard of, were more talked about by people than her art itself. Today, however, she is recognized as the incredible artist that she truly was.

Ayesha is by far one of my most intelligent, charismatic, innovative, and hilariously witty friends. She asked me to tattoo Artemisia Gentileschi's version of the Judith and Holofernes story, a tattoo that makes sense in light of Ayesha's commitment to developing her feminine strength and power.

I always walk away from an interaction with Ayesha feeling inspired and motivated to take on the world. What I admire the most about her is her strong sense of being connected to who she truly is. She is a lively spirit who feels free to think and say whatever she pleases, dress however she wants to, and creatively apply herself however she sees fit. She's got a great energy and embraces her own power. She'll be the first to tell you that being a strong woman means ignoring

the female stereotypes that we are manipulated into following from an early age.

"We are definitely not the fairy-tale-seeking little girls we were told we were," she once said to me, and I agree.

Over the years of knowing Ayesha, more than once have we found ourselves being grateful for the strong women surrounding us, whether they are friends, family, or coworkers. None of us are living the conventional lifestyle we were taught was the norm when we were growing up. We know what works for us, and we're living our lives that way.

The fact that Artemisia Gentileschi painted a portrayal of female strength at a time when the world shunned our power, was reason enough for Ayesha to choose this specific version of the story of Judith for her tattoo. This painting is a profound symbol of strength that is inspiring to women and to anyone who is courageous enough to follow his or her own path, especially if it's a path less traveled. ✢

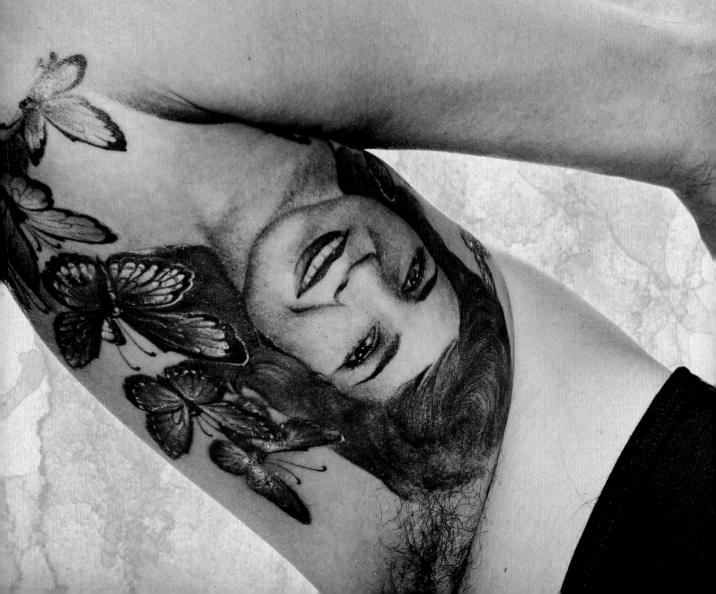

Adrian Gallegos

hen you look at the High Voltage Tattoo family tree [see pages 72–73], it can be easily traced back to the two people whom I hired initially: Dennis Halbritter and Adrian Gallegos. From these first two the rest of our existing crew branches off. With the exception of the few people who have come and gone here and there, the High Voltage family has largely retained its original members.

Dennis, the first person to join me in this wild roller coaster of a shop, and Adrian are both very close to my heart. Not only are these guys well-respected, established tattooers, but they believed in me and my vision for High Voltage Tattoo before anyone else did.

The first time I heard about Adrian, I was nineteen. Without knowing very much about him as a person or even having any idea what he looked like, I formed an opinion of him based solely on the array of beautiful tattoos that he had done on the clients who had circulated through the shop where I worked. Before long, I was so familiar with his style and unique approach that I could instantly pick an Adrian Gallegos tattoo out of a lineup of hundreds: delicate, immaculate line work created with finesse and solid but flawless gradations of color. Most impressively, the composition of Adrian's tattoos could convey so much feeling and emotion. I could tell that even the smallest butterfly tattoo had been thoughtfully drawn by a creative mind.

From my perspective, the story of how Adrian and I finally met is comical. Late one night, I went with a friend to the Pacific Dining Car—a restaurant downtown. It was upscale and famous for being open late, and I would often see familiar faces there. We enjoyed a great dinner, and as we made our way toward the exit, we were stopped by a dashing gentleman with kind eyes and a stylish scarf around his neck. Politely, he introduced himself.

"I'm Adrian."

Without knowing his last name, I already had an idea whose hand I was shaking. I don't remember exactly what I said, but I do remember gushing like a geeky fan.

We didn't cross paths again for years, but I often thought of him. What I never imagined is that I'd become his peer, and more importantly, that he would become such a solid friend.

When I opened High Voltage, Dennis and I were pretty much holding down the fort. My insecurities at that time had me convinced no experienced tattooers would want to work for me—a twenty-four-year-old girl running a newbie tattoo shop in West Hollywood. But when Adrian walked in one day, to congratulate me on my new business, I somehow mustered up the courage to tell him that if ever he felt he wanted to make a change of scenery, I was a phone call away.

The rest is High Voltage history: after Adrian joined us, he introduced Khoi Nguyen into the shop, and our family continued to grow slowly but surely. Now there are about twenty guys and gals working side by side, day in and day out, and with every personality so unique, the dynamic has become quite interesting. Some of my tattooers come fully loaded with type-A personalities, while others aren't exactly loud and talkative, but all in all, we work best together. After a half decade in business, I can

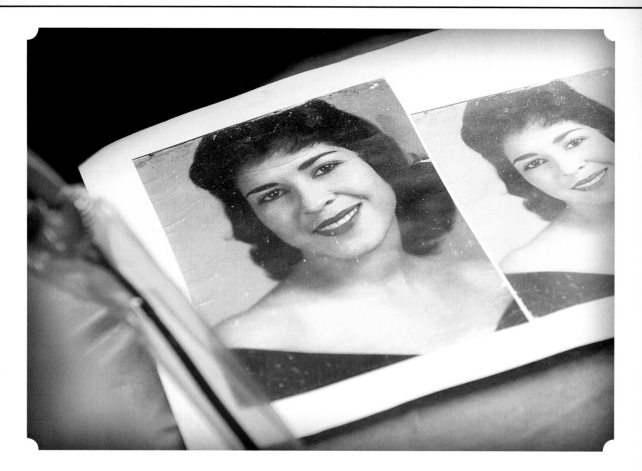

confidently say that we all truly love one another.

Adrian is definitely one of the more introverted guys at the shop. He's quiet, but he isn't necessarily shy. He's respectful and reserved, but also hilarious and smart. At our monthly shop meetings, he rarely speaks up but when he does his message is always important. That's something I love about him. I, on the other hand, clearly talk too much!

I get the feeling Adrian thinks I don't notice when he quietly watches me tattoo. He'll study what I'm doing, and every so often, ask a question. I also don't think he realizes how much of a compliment it is when he asks my opinion or advice on his approach to a tattoo he's working on. In the past year alone, his portraits have surpassed mine in so many ways, and it's an incredible thing to witness.

When Adrian asked me to tattoo him, it was a big deal for me personally because of our relationship, but also because he's a tattooer whose work I admire. But given what I've just said about his portraits, you can only imagine how I felt when he asked me to tattoo one of his lovely mother! No pressure. Yeah, right.

The vintage photograph that he chose was taken around 1954 and was perfect for tattooing in every way. Adrian's idea for framing his mother's face with different shades of blue butterflies made it even better.

Since I've known him, Adrian's had his right arm bare of tattoos, so the fact that he wanted to place the portrait on the inside of his right bicep made it an even bigger deal. He chose this tattoo because his mother is such an important person in his life, and he wanted the tattoo to be a constant reminder of who she is, what

she means to him, and her personal strength.

Adrian's mother, Esther, knows what it's like to be resilient during times of great weakness. Her father abandoned her family, and she grew up in very poor conditions, beginning work at a young age in order to support herself and her mother and sisters. At twenty-three, she married Adrian's father and started what would eventually be a family of five children. She also opened a gift boutique and women's clothing store, which she's now run successfully for more than thirty years.

Adrian admires his mother's strong work ethic and honesty. Always one to speak her mind, Esther was never afraid to express her opinion and to stand up for what she believed in. From the way Adrian talks about her, I can tell she always remained positive regardless

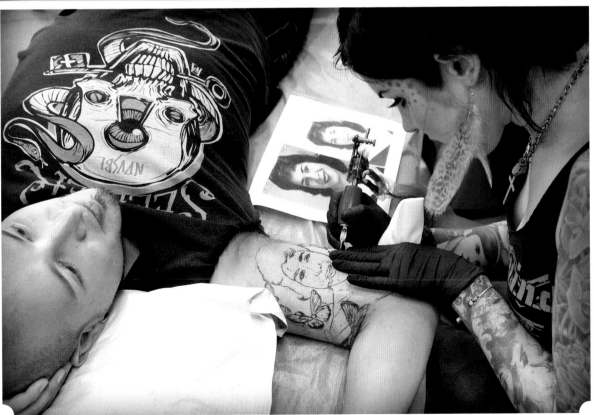

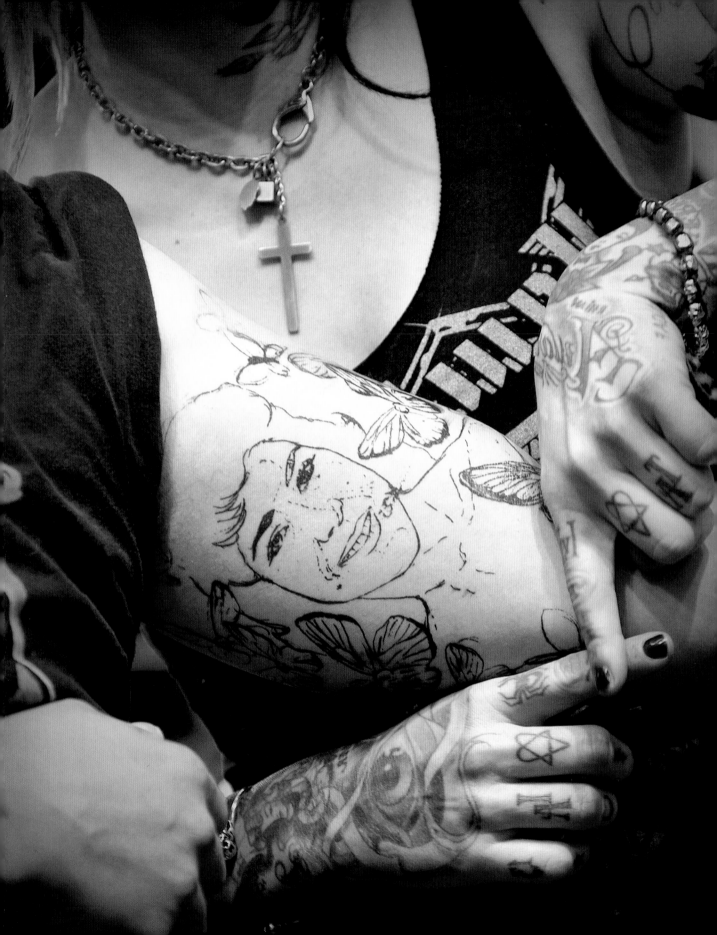

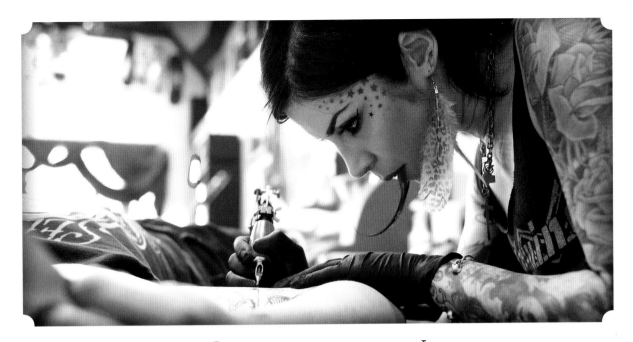

of how challenging life's circumstances were.

When Esther became sick, it was a shock to everyone. She was always healthy, never drank or smoked, and watched her diet. So when she was rushed to the hospital with a life-threatening infection, it was a wake-up call to Adrian to honor his loved ones now, so he wouldn't have any later regrets about his family relationships. Even though his relationship with his mother is a close one, that event brought her importance to him into sharper focus—and he made connecting with her a daily priority. Adrian had always wanted to get a tattoo in his mother's honor, and after she recovered from her illness, the idea of showing his love for her in this way became even more important to him.

Adrian knows that he was lucky to get a second chance with his mother. Every day since her recovery has been an opportunity to tell her how much he loves her, and this tattoo serves as a permanent way of expressing that. ✠

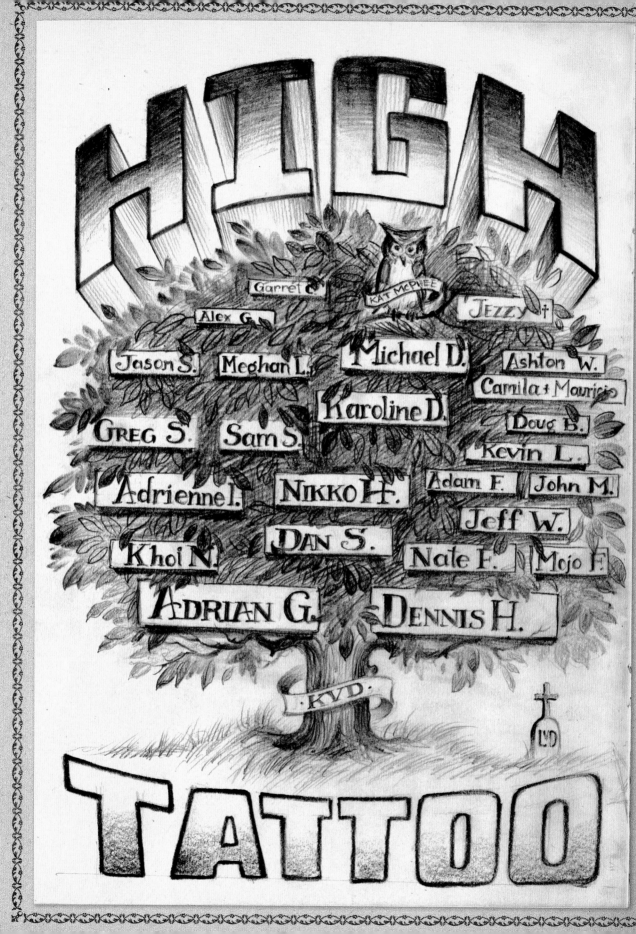

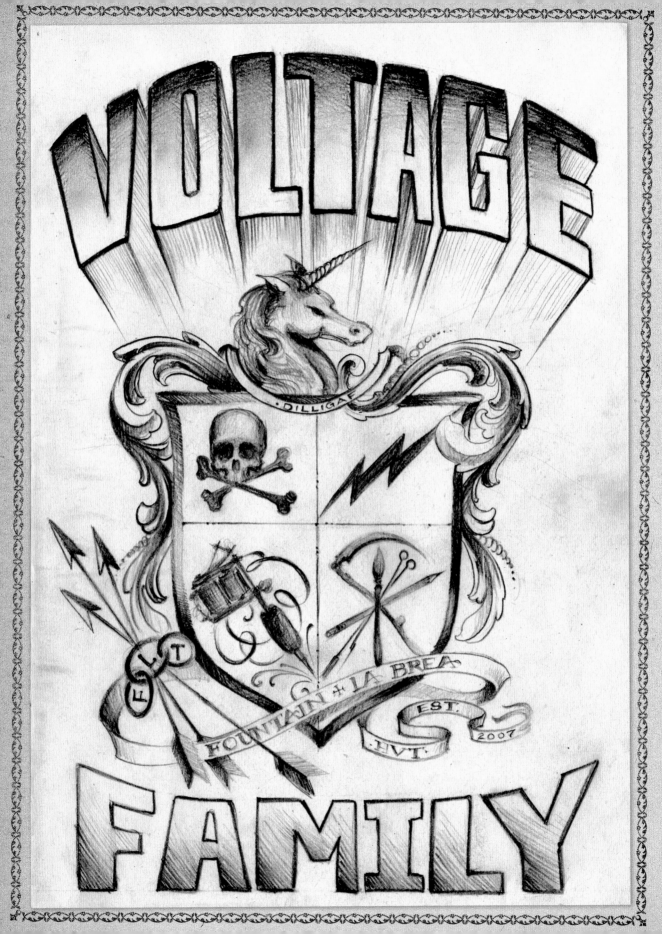

Game

When I cross paths with someone I wouldn't usually meet in my day-to-day life, and when those unexpected interactions blow me away, that's the part of my life I sometimes wish I could share with the entire world.

I'll be the first to admit it. As much I consider myself a fan of a wide array of music genres, I really don't know very much about the world of rap and hip-hop. But just because I'm not familiar with something doesn't mean that I can't possibly relate to it in my own way.

I had tattooed Game before and was impressed by his sincerity. I was also really impressed by the depth of his insight on so many levels. It only makes sense that someone with his cleverness and intellect would have a knack for words and would be able to innovatively translate those lyrics into songs that are embraced by millions.

During the first tattoo, our conversation naturally drifted in the usual directions; where he came from, the music industry, upcoming projects, and such. All those things are interesting, but they only scratch the surface.

This second time around, Game wanted portraits of all three of his beautiful children on his leg. In order to appropriately size each face, the final tattoo had to extend from the bend of his knee all the way to his ankle. Just like the first time I tattooed

him, Game was calm and generally just nice to be around. He showed no signs of hesitation or anxiety as I sized and graphed each portrait onto my line drawings and set up my station.

Moments spent listening to dads tell me all the things that their kids do to light up their world are sweet. Game's demeanor softened as he talked about each of them while I traced out the details of their faces for the stencil.

Game had a rough childhood and, in the process of taking control of his life, he was able to channel strength from his challenging experiences. It's typical for people to repeat the dysfunctional patterns of their childhood—even when they were deeply miserable as a result of them—without even realizing it. Because Game didn't want his own kids to have to deal with the hardships that he endured as a kid, he found the strength and will to wake up every day and be a good father, provider, and leader—and this extensive tattoo of his children represents that commitment. He sees strength as a form of courage to take control over your own destiny. I connected with his attitude because I am a believer in our ability as individuals to create the reality around us. It may sound like a cliché, but I truly believe that where there's a will, there is a way.

Game said that as willful and determined as he is, his true strength comes from the support of his family. I asked him what message he wants to give the world through his music, and his answer blew my mind. "It would be the biggest gift of all," he said. "Love! Because it takes that and that only to move mountains down here on God's green earth. Love."

I was humbled by Game's acute awareness of the important things in life, and honored to be a part of this exchange. He got a tattoo of his kids, while I got to take away an inspiring reminder that there is still so much goodness in this world. ✚

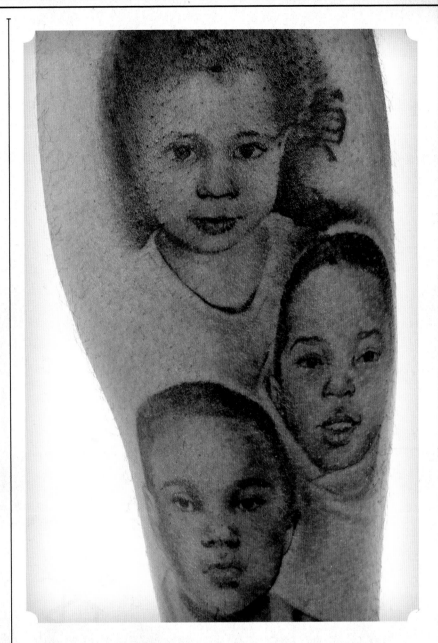

"I am strength and strength is me." —Game

EARLY

2009

e's the reason why I wanted to write music to begin with—and learn to sing.

I remember the exact moment I made up my mind about making music. It was something I felt I needed to do, not for any reason other than as a way to respond to him. It didn't matter if the songs I'd write ever saw the light of day, as long as he was able to listen to my music, my message him.

He had told me to look for a package at my doorstep, prefacing the delivery of the contents, his new album, by saying, "These are all the things that are easier sung than said."

I knew what he meant, but never imagined each song would be filled with direct messages to me. I put the album on, and the music rushed out of the speakers and filled my house. His voice rang all around, making its way to the core of my heart with every word he sang. As cryptic as those lyrics might have been for anyone else, I knew exactly what each word meant and recognized every event and place he referred to.

The songs were so beautiful. I just wished so badly that he could have said everything out loud just once to me. How should I respond to something like this? Where do I even start?

"Creativity is an act of defiance."

—Twyla Tharp, THE CREATIVE HABIT, 2003

One of the most common remarks I hear from people when they see one of my sketches or tattoos is: "I wish I could draw." It's flattering, but a part of me cringes at that comment simply because it isn't true that they can't learn to draw. There's nothing special about what I do. Technically speaking, anybody can do what I do, maybe with the exception of those who have certain physical disabilities, and even then, there are people who are able to draw, regardless of physical challenges. Drawing well only requires practice, devotion and dedication, will and drive, and practice and more practice.

Tests show that it takes the average mind approximately ten thousand hours of practice to achieve mastery of something—whether in sports, video games, music, science, or art. It sounds crazy, but anyone can master anything if they so chose. Of course, I'm speaking about the technical approach to doing it, recognizing that practicing it passionately doesn't give you the results you desire overnight. But there is a lot of power in knowing the potential capabilities of both your mind and body.

We have a frequency in us that lets us recognize great art when we experience it. Great art awakens a spiritual part of ourselves.

If you definitively knew that you were capable of mastering anything, then instead of seeing that very skill as a gift from above that has been randomly handed down to a select few, what is it that you would do? The options are so very endless, and imagining a world where no one was held back from creativity by fear is a beautiful thing!

It makes me sad when I hear people say that they "wish" they could draw. If you want to, you can. When people say, "I could never do that," all I can think of are the missed opportunities to create something beautiful.

Some people say they are not creative and in the next breath, they say they love my art. And I want to say: "If you believe yourself to be the furthest thing from a creative being, then

WHEN WE FEEL STRONG ENOUGH TO BE OUR TRUE SELVES, THEN WE HAVE THE POWER TO EXPRESS OURSELVES UNIQUELY.

how is it that you are able to recognize the quality in my work?" I believe that if you can recognize the quality of any sort of creative work, then it means that you have that ability, too.

The simplest of tasks can become a platform for creativity if you have the right mind-set. Just because you can't paint the Sistine Chapel like Michelangelo or compose a symphony like Beethoven does not mean that the power of creativity cannot flow through you. Some of the most creatively inspired people I've met were far from "accomplished" artists. They are busboys at bars, waiters and waitresses, puppet-makers, and mothers and fathers.

When you acknowledge that there is a deeper sense of creativity inside of you, you can become in tune with it. And when you do that,

you can bring that awareness to everything you do—and a greater awareness to everything you make. The result is that whatever you do or make has a freer, more personal quality to it. You have to nourish your creativity for it to flourish, just as paying sincere attention to another human being's needs and feelings raises the quality of a relationship.

Why does music move us? Why does poetry inspire? Why do we feel when we witness great art? Because we have a frequency in us that lets us recognize great art when we experience it. Great art is special in that way because it awakens a spiritual part of ourselves.

When we are comfortable with our individuality, when we feel strong enough to be our true selves, then we have the power to express ourselves uniquely, to create something that comes from our own experiences and feelings. Some of my favorite singers are not technically the best singers, but they are able to use their voices and their songs to convey messages, which in turn affect and inspire those who know how to listen.

Whenever I doubt myself, which happens more often than some people would bet, I try to remember what Eckhart Tolle said about creativity: "What you do is secondary. How you do it is more vitally important than what."

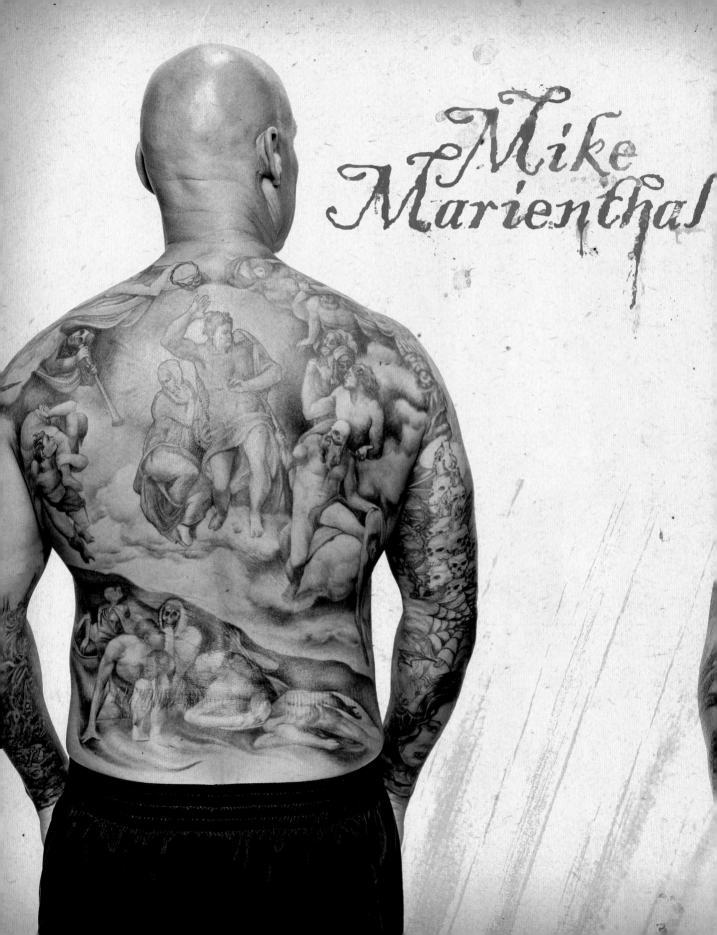

Mike Marienthal

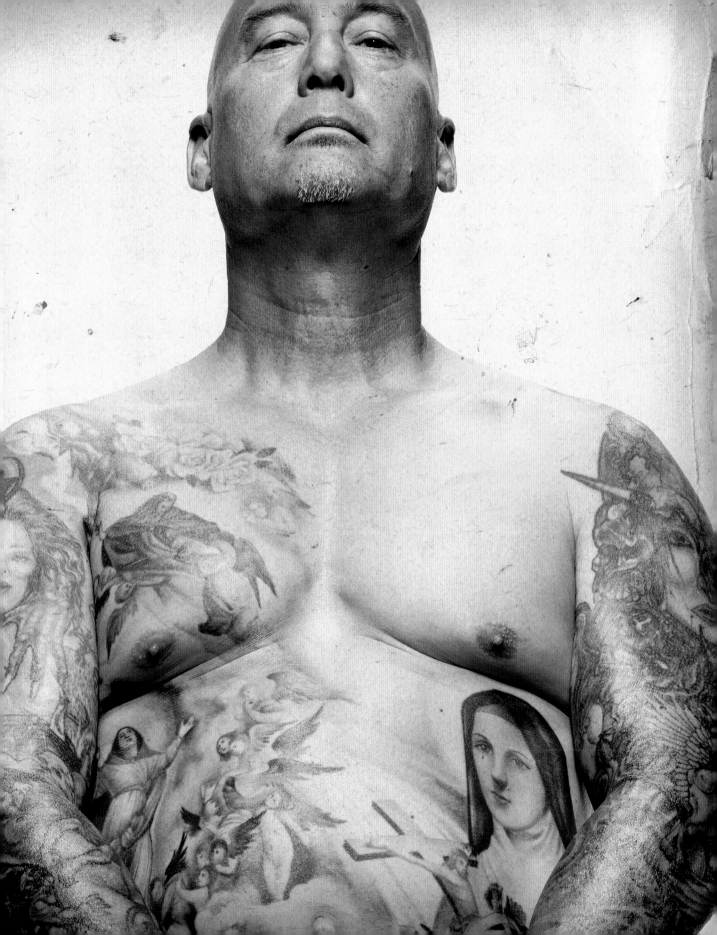

ut of everyone I've been lucky enough to tattoo, Mike has one of the largest collections of some of my favorite tattoos. We have great communication, and for the most part he can give me a vague description of an idea and somehow I always fully understand what direction he wants to move in. For Mike, these tattoos are spiritual, signifying his commitment to Catholicism, to which he converted—and converting to Catholicism is an arduous process. For me, the collaboration with Mike is always liberating. He allows me to create with very few boundaries. He trusts me, and we respect each other. Of course, it helps that he is always prepared with plenty of reference, and that we happen to share the same passion for Old World Catholic-inspired artwork. Whenever I look at my calendar and see Mike's name scheduled, I get happy.

Over the last five years, Mike and I have completed massive tattoos on his calves, thighs, abdomen, and chest, leaving us with the grand finale: his back. When he presented his idea of doing a rendition of Michelangelo's *The Last Judgment,* I was elated. I've spent hours studying this masterpiece, so I was more than familiar with its intricate nature. Michelangelo's work in the Sistine Chapel exemplifies how a great creative spirit, well-practiced skill, and extraordinary hard work came together beautifully to create a timeless masterpiece. As such, his art is a great teacher! As a tattooer, I'm inspired by him, particularly when I'm working on complex pieces and translating them from two-dimensional, flat surfaces to the three-dimensional curvature of the human body. I have to pay close attention to space and detail.

I knew that although Mike wanted a large piece, and his back offered the largest space available to create this tattoo, we would be working in a far

more restricted space than the vast space that Michelangelo had available to him— the altar wall of the Sistine Chapel. Including 100 percent of the fresco would be impossible without losing important detail, so we strategically chose elements from it, composing our own rendition while staying as true as possible to the original work.

Graphing out Mike's back was the first step. Together, we took the photos and books of reference, and like working on a puzzle, we carefully pieced together a line drawing. Although we knew we had to go through a process of eliminating certain elements of the work, it was important to demonstrate the same visual impact Michelangelo intended when painting it.

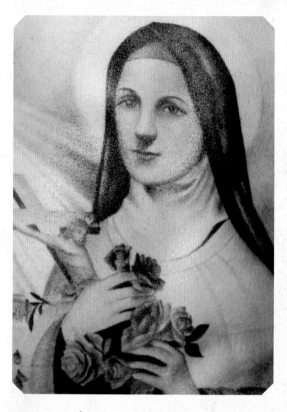

The Last Judgment was the subject of Michelangelo's last composition. The fresco is made up of clusters of figures, including angels with the symbols of Christ's passion, and the figure of Christ, the judge, with the Madonna beside him in the upper portion. The central part is a spectacle of citizens who've passed through the divine judgment: the elected at left are ascending to heaven, while on the right, the damned are desperately falling to hell. The piece is a monumental flurry of human figures, all presented in every possible attitude conveying every imaginable human feeling and desire.

Michelangelo's ability to capture contrasts of light and shade is something I highly admire. I knew capturing that sense of light would be key

to encapsulating the same amount of dimension and depth in Mike's tattoo in order to avoid making a giant mess of things. My goal was to make the final piece remarkably striking, from afar and also from up close, in the same way the fresco does.

Mike is very experienced with and understanding of the tattoo process, especially with large-scale tattoos, and this helped me a great deal. Tattooing *The Last Judgment* took six sessions, and we spent three or four hours working each time. Mike's patience and endurance were critical to the success of the piece!

At the end of each and every session, the gratitude was unanimous. We both walked away feeling like we had been able to spend time with a good friend.

One day, I'd love to see firsthand *The Last Judgment* along with the rest of Michelangelo's body of work in the Sistine Chapel, but until then, admiring it through this tattoo was fulfilling in every way. ✛

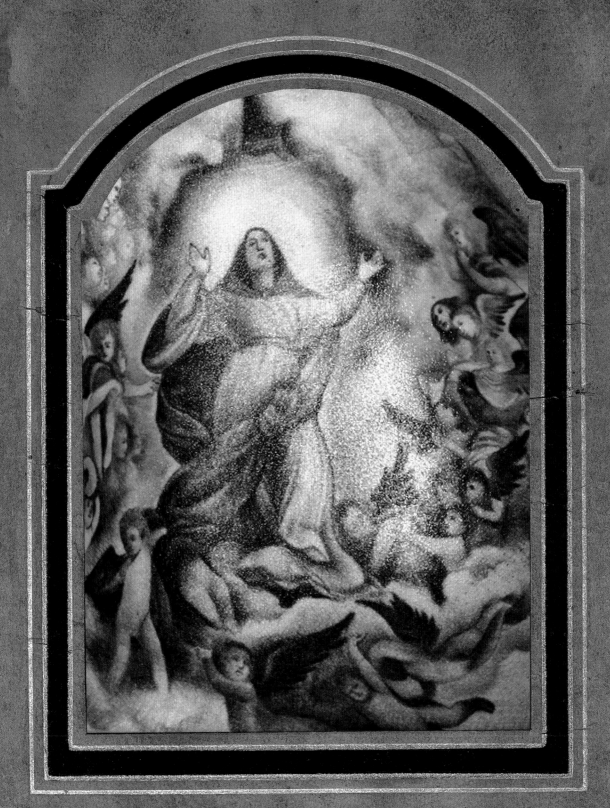

Lacy Soto

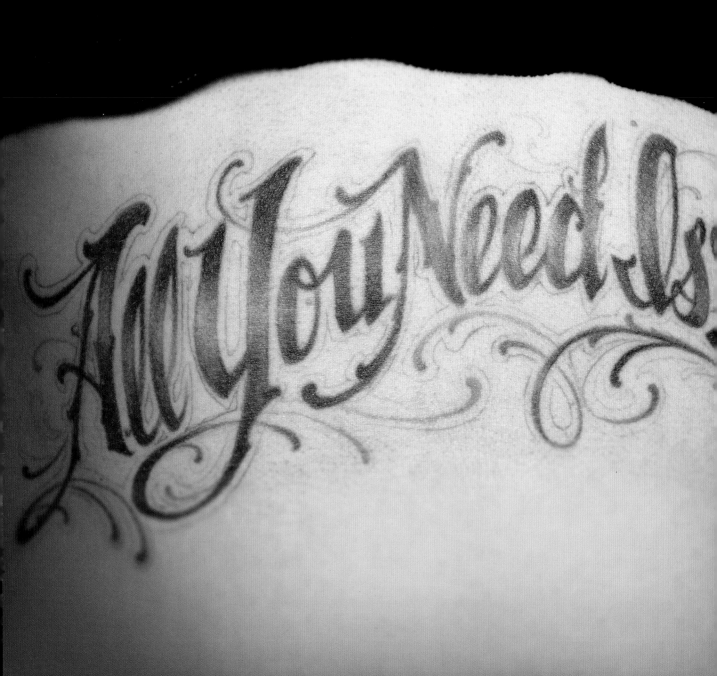

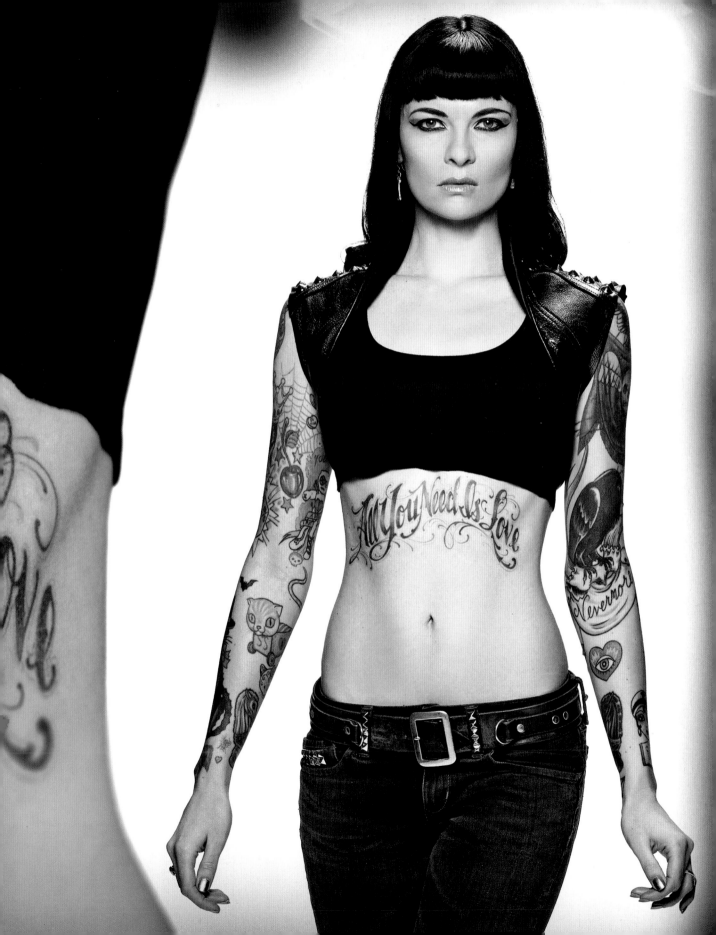

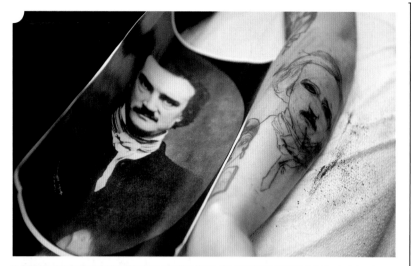

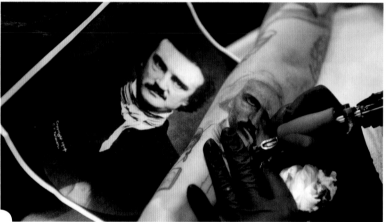

The first and only oil painting I ever began and completed is a portrait of Edgar Allan Poe. I was inspired by watching Kevin Llewellyn paint a picture in front of my fireplace one rainy night. As he worked on a canvas, sitting with his legs crossed on the floor next to me, I studied his techniques over his shoulder, soaking up whatever little bits of information I could. Kevin made it look so easy, and every stroke had a grace and finesse that I aspired to.

As soon as Kevin went back to his loft in downtown LA, I picked up my brushes, paints, and a piece of wood. I knew exactly the image I wanted to translate onto the wood: the classic portrait of Poe, complete with his wild, raven hair, and sad, sad eyes.

Poe captivates me. He was the first well-known American to try to earn his keep through writing only, and although we all know Poe now, he was not a financial success during his lifetime. But he still kept creating, writing poems, short stories, and mysteries. The fact that Poe trusted and was motivated by his creative vision even when his work didn't always get the accolades he deserved inspires me. If artists pursued their visions with applause or acceptance in mind, no one would create anything worthwhile. Making art should be about creative fulfillment, and that is something I always try to remember.

I spent hours making the brush strokes of blacks, indigo blues, and cool grays take shape. My goal was to give the painting to my best friend

and neighbor at the time, Danny Lohner. He was an even bigger fan of Poe than me. The idea of giving this little painting to him motivated me to work through the night to finish it.

Days passed as I waited for the glaze to dry enough so that I could frame it and present it to Danny. More days passed. My inner procrastinator kept saying, "I'll frame it tomorrow!" long enough that eventually the painting became a joke between us. Danny would laugh at the thing and call it *Danny's Painting That He'll Never Actually Have.* Even as I write this, I confess, I still haven't given it to him—procrastination!

Before that, though, while I waited for the painting to dry, I had taken a photo of it and was using it as the screen saver on my laptop. Little did know I would end up tattooing my painting on someone. When Lacy saw it, she flipped out and announced that this was the Poe tattoo she had always wanted.

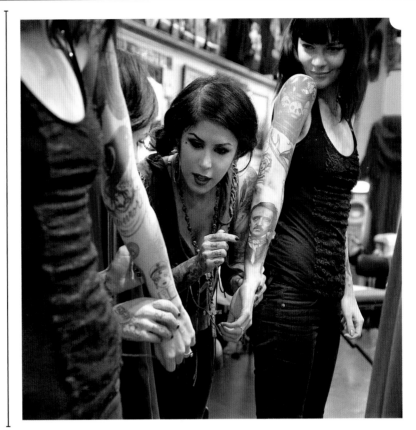

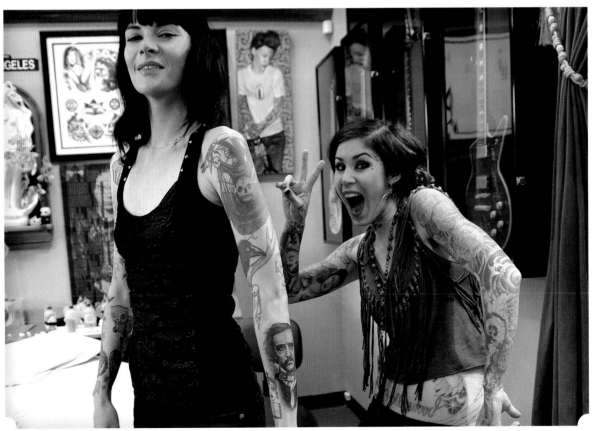

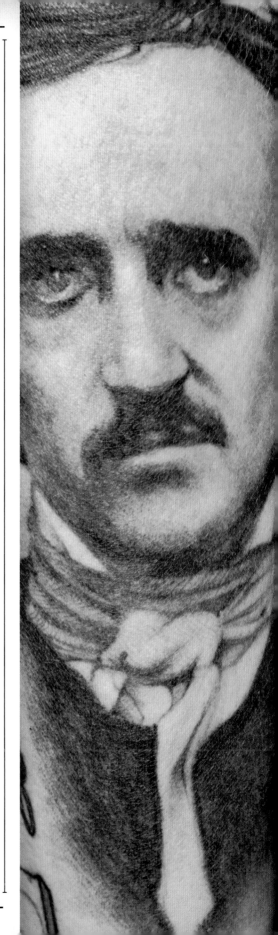

At the time, I was shooting images for my last book, *The Tattoo Chronicles*, and Lacy was playing Winter for my series of the four seasons. Lacy made a beautiful Winter. Her hair was as deep black as Poe's, and her exotic features were that of a fairy-tale character, with high cheekbones, fair skin, ruby red lips, and an icy stare every time the camera went up. Those images are still some of my favorites out of all the photos that I've ever shot.

"I always wanted to get a portrait of Edgar Allan Poe. And I've been saving this spot right here for just that," she said, running her hands over an area of blank skin on her forearm. I agreed immediately, since I loved the idea of tattooing that image, particularly since I was familiar with every single aspect of it.

It took years for us to make that tattoo happen, though. Lacy wound up working at Wonderland, and we became close friends. We have many things in common, but our strongest connection comes from our love of daily meditation. Talking with Lacy about the power of a meditation practice always makes me feel less alone.

Before we did the Poe tattoo, though, Lacy asked if I would tattoo her with a script tattoo of the phrase, "All you need is love." This is also the title of a book written by Nancy Cooke de Herrera, my transcendental meditation teacher. Lacy wanted "All you need is love" to scroll delicately across her abdomen, stretching from rib to rib.

While I tattooed the piece, we talked about how meditation plays such a huge role in our creative lives. Meditating removes the boundaries between the conscious and unconscious mind, and helps people tap into the creative fire that burns in all of us, whether we are aware of it or not. The tattoo turned out beautifully, a credit to Nancy and her teachings as well as to Lacy and her commitment to her creative endeavors.

A few months later, Lacy was ready for her Edgar Allan Poe tattoo. The key here was to not only capture Poe's essence in the tattoo, but really play up the dramatic contrast of dark and light to give it as much of an eerie feel as possible. Stretching from her wrist up to her elbow, the portrait fit perfectly, and suited her to a T. ✢

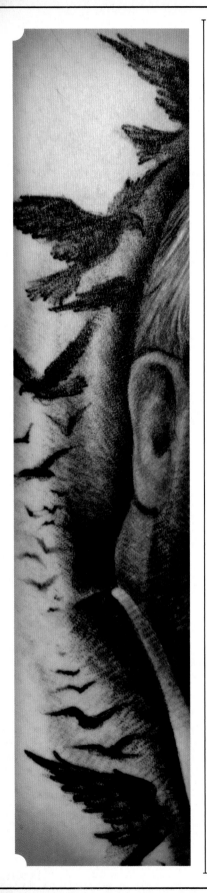

Chris Flynn does special effects for TV and film, and Alfred Hitchcock's films are among the main reasons he went into his line of work. "Hitchcock is such a terrific director," Chris says. "He was the first director whose films showed me that movies could be more than entertainment, that they can be art." After seeing so many different renditions of portrait tattoos of Hitchcock, Chris wanted to approach his tattoo in a unique way. Instead of getting a traditional portrait, he wanted to incorporate into the portrait elements that related to the director. Adding these other elements made the execution of this tattoo a more creative and challenging process.

One of the most difficult aspects of this tattoo was replicating every wrinkle, crease, and pore on Hitchcock's textured face. To me, these are some of the more fun parts of the job—being able to home in on the microscopic details that really make a tattoo come to life.

Hitchcock's profile is as familiar to his fans as his films, and his shadow has become one of the most recognizable silhouettes, known worldwide. Incorporating the shadow into the portrait itself was tricky at first, and we had to flip through several profile images to accurately impose the shadow onto the tattoo. Adding this in the background framed the portrait so beautifully, but left a large open space on the back of Chris's calf.

During the preparation of the line drawing, Chris mentioned his love for *The Birds*, so what better element to use in this composition than just that? I imagined a thick blanket of birds aloft in the background. By using layers of blacks and grays and even deeper blacks, I could give the feel of a dense flock of feathered wings, giving the tattoo not only a perfect balance of background on each side, but an equally spooky vibe, appropriate to a portrait such as this. ✛

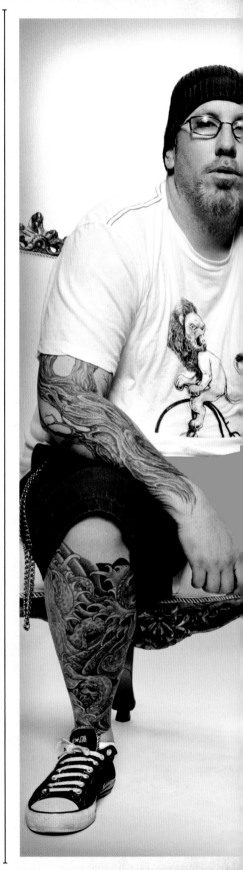

CHRIS
✦
FLYNN

"If I won't
be myself,
who will?"

–ALFRED HITCHCOCK

Alfred Hitchcock: Interviews, 2003

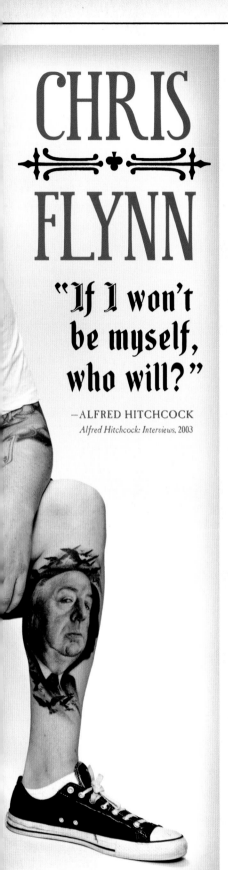

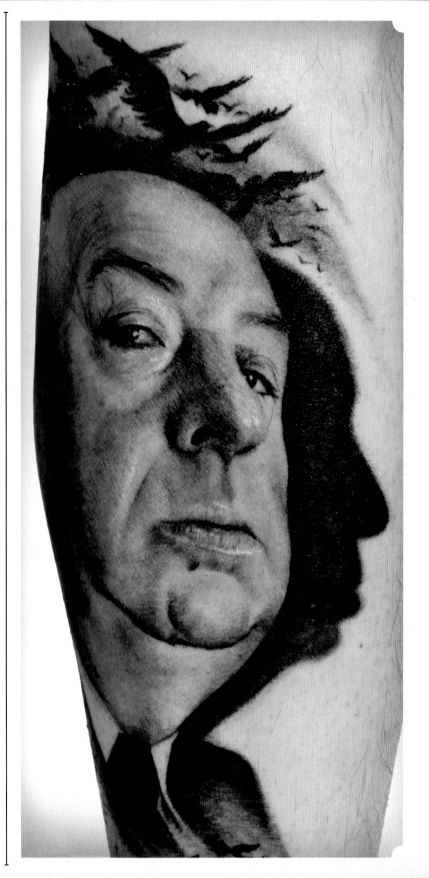

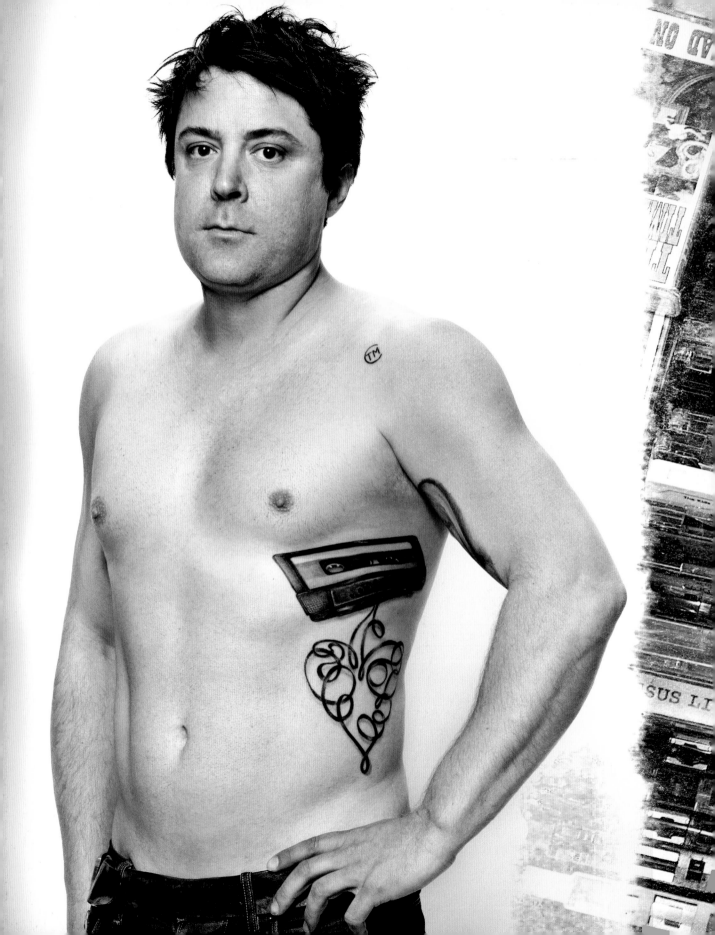

Tony said the most heartfelt thing when I tattooed him. What he said was so simple, and I believed every single word: "Music is the only language I truly understand. Playing music is the only time I ever feel free."

He's been listening to and playing music long before MP3s were around. Given that, it makes sense that Tony chose to get a tattoo of a cassette with the tape unraveling in the shape of a tangled heart. Music is what moves Tony, and this tattoo makes it irrefutably clear that music is his passion.

Tony started playing music at the age of five. I love the story of how he got his star, a monumental moment that he refers to as "The Night He Became a Drummer." Sitting at the dinner table with his father while his mother was making fried chicken, Tony started beating on the table with his utensils. His father, who a drummer himself, looked over in astonishment, and his mom turned back from the frying pan and said, "You might have to bring out the drums!" And the rest is musical history for Tony, who has played in bands all his life, eventually becoming the drummer for the American desert rock band, Fatso Jetson.

For me, tattooing has been the most consistent thing in my life, second only to music. Music is my language, too. It speaks to my core through song and tone, and often times without words. In spite of the fact that my friendship with Tony was the outcome of our first conversations when I tattooed him years ago, our shared passion for music is what's made us close. When Tony and I get on the topic of music, hours pass by like minutes.

As a friend, I confided in him about my recent fears in singing, and how much I was struggling to be free of those thoughts that were holding me back from recording. After listening to me, he shared some feelings that I was surprised to hear. Tony told me that there are books and poems he's longed to write and songs he would sing if only insecurities didn't get in the way. I understood, but I was also confused.

Having heard Tony say that music frees him, and having watched him perform on stage in front of large crowds of people, I would have never guessed that he too gets scared about performing. If music gives him such profound feelings of liberation, then why would he be scared to share it? He told me, "It's one thing to sing out your most intimate lyrics to yourself in a lonely room, and it's another to reveal parts of yourself to the rest of the world." Tony's comfortable when he plays songs that he and his bandmates have composed together,

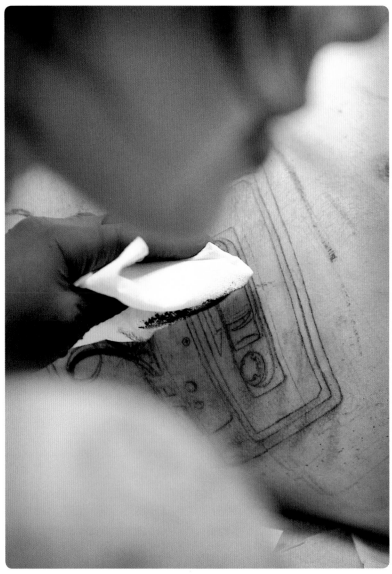

but outside of any other projects he's been a part of, he's kept his many solo ideas to himself, in check, out of fear.

I understood just what he meant. Lately, the idea of singing in front of people frightens me more than anything I've ever experienced. Maybe it's the amount of utmost respect that I have for quality music, and my fear of not doing the art justice. Maybe it's because I want to do it so badly that the idea of failure is getting in the way before I even have a chance.

Tony admires my courage in writing books like the ones I've published, in tattooing with cameras all around me for the audiences who tuned into *LA Ink*, as well as in putting myself out there in photo shoots and meet and greets with fans. Meanwhile, I envy his ability to put himself out there in the form of song in front of the entire world. Honestly, listening to Tony reveal some of his anxieties about music inspired me. I felt a little less alone and a little bit more motivated to try, because if my friend Tony can do it, I can too. ✛

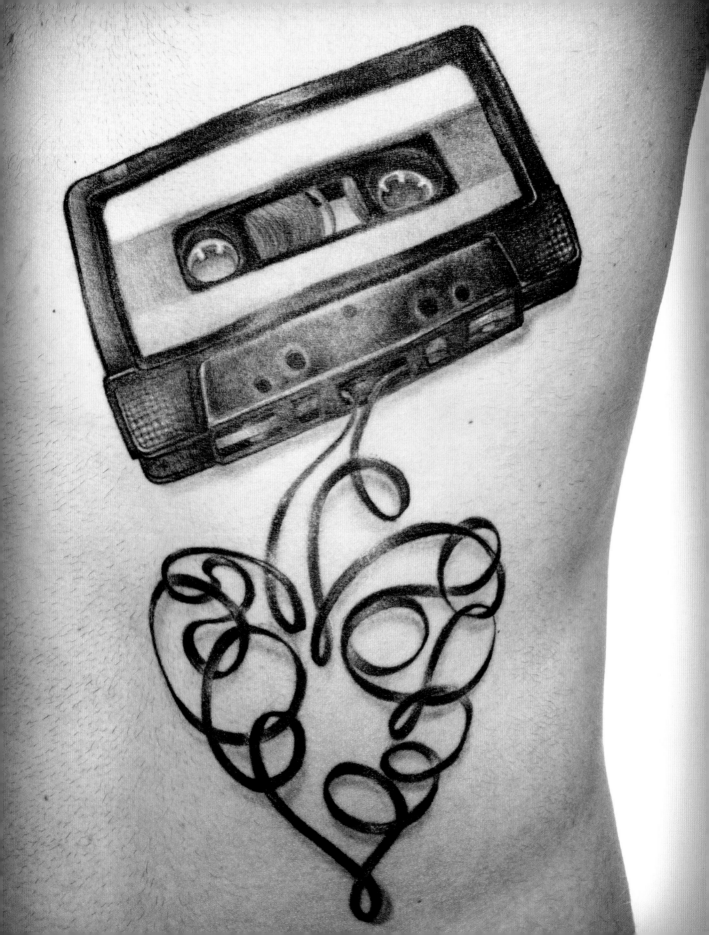

Billie Joe Armstrong

The older I get, the more and more I seem to be in touch with what some people refer to as "gut instinct." Others refer to this inner sense of knowing as intuition, or even telepathy. I really don't know what it is and have little interest trying to define it in words. But being acutely aware of the direction that the universe points me in, makes it easier to go forward. Lately, I've been trusting that feeling: if I feel compelled to take certain actions, I don't question why, I just take them. Somehow I don't feel it's important to fight these feelings; it's more important to listen to myself and just go with the flow.

When a friend asked me about whether he could introduce me to Billie Joe Armstrong regarding a tattoo he was looking to get, I felt totally comfortable passing along my number. Billie Joe and I connected, and after a few text exchanges in which he described his vision for

the piece to me, I was confident and excited to do it.

The more pressing issue was that a while back Billie Joe had promised himself that by the time he turned forty, he would fill the empty spaces on his right arm with tattoos that he had been thinking about for quite a while. His fortieth birthday held great importance for him when it came to this particular goal. The only catch was that Green Day was on the verge of recording their next album, leaving him no time at all to fly from Oakland, where he lives, to Los Angeles for a tattoo—even if it wasn't the longest trip.

I haven't tattooed outside the walls of my comfortable tattoo shop since the beginning of its grand opening five years ago, and I prefer not to. I have everything I'd ever want at High Voltage: my crew, my machines and supplies, my music, and an overall inspiring environment. Trading that in for what was most likely to be an uncomfortable setting in someone's

house or a hotel out of town has never held any appeal for me. But something told me that I needed to go to Oakland. I didn't know what it was exactly, but I just sensed that there was something that I needed to hear from Billie Joe—and that would only happen if I flew up there and tattooed him. So without telling him—or anyone else, for that matter—why I'd decided to travel to tattoo him, I flew to Oakland.

Billie Joe had e-mailed me files of references, including different ideas, elements, and photos of his preexisting tattoos. The areas I would tattoo included a large empty space on the inside portion of his bicep as well as the space around his elbow. The plan was to add the new tattoos and seamlessly join them to the surrounding areas. I didn't know whether at Billie Joe's house there would be a proper copy machine/printer or any of the drawing tools I use, so I prepared the artwork ahead of time. The blending was

something I would simply map out with a pen once I got there.

A black and gray anchor wrapped in a flowing banner with the words "St. Jimmy" filled his arm nicely. As I laid out the stencil, Billie Joe came up with the idea of adding a Jolly Roger–style pirate flag in the background, and I agreed that the subtle textures of an old and decrepit flag waving in the air behind the anchor would work perfectly.

Once that section was complete, we moved on to the less technically challenging aspects: adding the stars framing his elbow, and black and gray roses to the right of the stars.

Like a trooper, Billie Joe sat through the session without ever showing any signs of pain. We were covering a lot of highly sensitive areas, and I was grateful for his endurance.

Toward the end of the session, we got onto the subject of music. We talked about all the different genres of bands that we grew up listening to. He told me the story of how he first got into music and compared what it was like to perform then to what it's like playing to huge crowds now. He was so humble when he talked about some of the great experiences he's been able to have due to the success of his band. Far too often, people who have received as much recognition as Billie Joe develop an ego that kills the magic. Living with gratitude for that success is far more impressive than cockiness could ever be.

Then we started talking about the weight of expectation, not only expectations of our fans, family, and friends, but the expectations we heap upon ourselves. We talked about how those critical thoughts can damage the creative process.

I often find myself second-guessing my art. "If I do this, will they like it?" "I wonder what people will say or think if I change this or say that?" "How do I make this better than what I've made before?" "I'm afraid I'm going to let people down if I don't do this or that."

So much thinking. Too much! We spend too much thinking, and too much wasted energy allowing outside voices and inner critics to dictate what it is we do when all we really want to do is allow inspiration and creativity to flow through us.

Billie Joe talked about some of the fears that come into play whenever he's recording. One might think that with the high degree of success that he's already attained, he wouldn't experience self-doubt. Of course that's not true. We talked about the fact that artists are human and all of them are sensitive to some degree—especially when they put themselves and their work out into the world. The key is to never lose sight of why you do what you do in the first place because with that kind of focus the only option is to work from a pure place.

Our conversation left me inspired, and I hoped, one step closer to freeing myself of the stage fright, and self-criticism I had been putting myself through about singing.

When I finally get the courage to record the album I'm writing, I'll be able to thank him for his insight and for the support I needed to express myself through writing and performing music. ✢

LATE
2009

he first time I saw him after I got sober, he was in town working on music. We sat in my office at the shop until the late hours of the night, talking and catching up about everything—music, home, art, and work. Did we talk about love? No. We constantly danced around our past instead. What happened to us? I couldn't find the courage to ask because I was scared of the answer I already knew.

We decided to draw. With paper and pencils in front of us, we sat at opposite ends of a table. He pulled my three-minute sand timer from one of the nearby shelves, and placed it at the center of the table. He suggested we draw each other, and I was game. With a flip of the hourglass, the grains of sand moved from one vessel to the other, and we began.

Sketching these timed portraits forced us to stare at each other, making it practically impossible to focus on the drawing itself. I had almost forgotten how beautiful his face was. He has a combination of eyes, lips, and a darkness to his looks that make him look almost otherworldly. With him, I felt like I was at the center of an orderly, tranquil, magnificent universe. For those three short minutes, there were no questions about life or purpose. It was as if we never needed any more from each other than this.

5

10

15

20

25

"*I never found the companion that was as companionable as solitude.*"

—Henry David Thoreau, WALDEN, 1854

When we first moved to America, my parents bought a small amount of land out in the middle of nowheresville, about an hour and some outside of Los Angeles. Coming from Mexico, and more specifically, a little town in the heart of Nuevo León where there wasn't very much around, it was as if my parents were trying to replicate that desolate life here in the States. The five acres of barren land were fenced in by a chain-link fence, and, aside from dirt and tumbleweeds as far as the eye could see, all there was was us.

While my parents were planning how to build our house with their own hands, the five of us were living in the two trailers my dad had somehow gotten his hands on. My sister and I lived in the smaller of the two, and my little brother and my mom and dad

in the other. There were no neighbors, no friends nearby to visit, not even a market or strip mall.

In order to spend more time with our family, my dad shut down the small clinic he had been running in Mexico, moved us all to the United States, and then had the overstock of medical equipment transported to our new property. Back then I didn't understand why my dad had so much equipment, but I knew that the equipment was why he had decided to build a warehouse on the large cement platform alongside our two little trailers. I never asked about his plans and didn't really care, because that span of smooth cement served as our roller-skating rink, and the hours my sister and I spent skating there were vital to our sanity during elementary school. Eventually, the warehouse walls were put into place, and the new building took over our rink. Tons of equipment appeared, seemingly overnight, and the giant storage unit was filled to the brim with stainless-steel medical tables, chairs, and lights. There were boxes of examination gloves and other random surgery-related items, all in shades of metal. The aisles of equipment towered over my seven-year-old body, and most of the time, I just found the place cold and frightening.

But one day while exploring I found an opening between stacks of freestanding medical screens and discovered a secret room just big enough for a child to sit in comfortably.

In private, I began to transfer my toys and art supplies from the trailer I shared with my sister to this new location in the warehouse. I spent hours there, just drawing, writing, and even napping. I don't know why I obsessed about it really: It wasn't very comfortable or well lit, and it smelled strongly of latex and rust. But the space was mine, all mine.

Looking back, I know now that it wasn't the sense of ownership that made me love that little place. The walls weren't really "mine": they were just overstock from my dad's old medical supply business that he would eventually one day sell off. What I loved was that the little space represented my first taste of independence. In the trailer, I was dependent on my parents and under their watchful eyes. In that room, I had freedom from all outside control.

As much as I loved my family, it felt good to be on my own. It felt good to take the reins of my own reality, even if doing so was only temporary. And it was never my intention to stray too far away from my loved ones.

I'm not so different now. I never imagined that I would love owning and running my own tattoo shop, let alone all the other businesses I've created. For many years, I was quite happy working for someone whom I respected, and I didn't require very much more. But when the opportunity arose to build my own shop and to set up my own tattoo family, the idea of that freedom made me feel alive.

I value my solitude, and at the same time, I'm not a loner. I thrive on surrounding myself with other creative people. I have no problem asking for help if I need it. But at the end of the day, I love coming back to a home that's mine, to a home that I've somehow managed to build on my own, with everything where I want it to be.

Material things are just symbols of the fact that I am capable of doing things independently. I don't need these things and I can live without them: what an empowering and freeing thing to know! Regardless of what the risks may be, or what anyone may say, or how difficult things become, I will always have an independent spirit that is mine alone.

"So, uh. What do we do?" I asked.

"First we take off our leather pants," said Brandon. "They smell like cows, and I'm sure the sharks would like that." He was barely able to hold in his laughter.

Brandon knew how deathly scared I am of sharks, and when he got me to agree to try surfing for the first time, this was his initial advice. Of course I was an easy target for Brandon's jokes considering I was dressed in my usual rocker attire at the beach and didn't exactly blend in with the rest of the beach bunnies and surfers in Malibu that day. So it wasn't hard for me to laugh right along with him.

An avid surfer who has spent hours and hours in the water teaching beginners like me to surf, Brandon managed to cajole me into the ocean, even though the thought of sharks frightens the hell out of me.

When I'm around someone like Brandon Lillard, it's easy to feel safe, especially when it comes to surfing. He has the gift of being able to teach without making learning feel intimidating or like hard work. I remember him asking me, after the millionth time I failed to stand on the board, "Are you having fun?"

"Yes," I said. I actually was, regardless of how bad I sucked at this surfing thing.

"That's the important part," he said. And he was right. For me, getting out in the ocean wasn't about becoming a pro. It was about proving to myself that I could do something new, regardless of the fear my mind generated whenever I thought about what I was doing.

Since I'd been struggling with my singing because of stage fright, learning to surf was an amazing exercise because it forced me to practice stepping outside of my comfort zone.

Brandon is fearless, which is something I've always admired, even

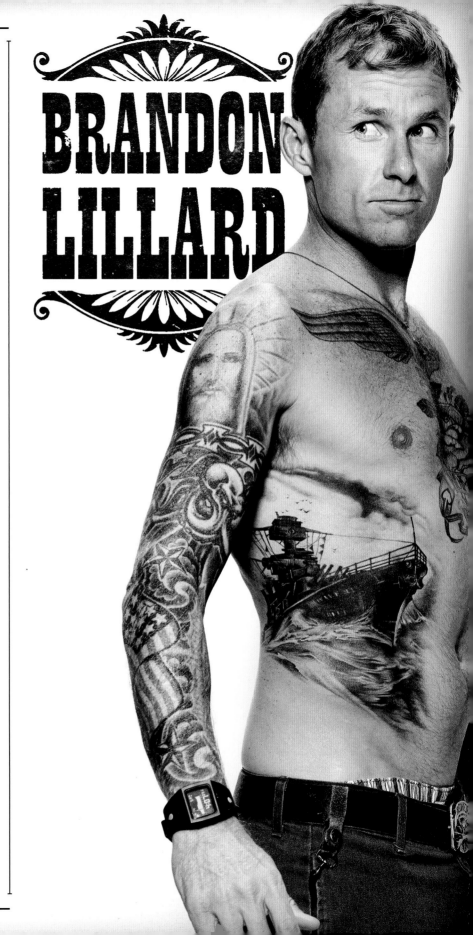

BRANDON LILLARD

envied. It's almost as if the things that frighten him the most represent challenges he needs to embrace and move toward, whereas most people would run in the opposite direction.

One Halloween, Brandon spent the holiday passing out candy with me at my house. My dad was staying with me at the time, and a most peculiar thing happened when he came home from work. As our conversation turned to our plans for the weekend, Brandon explained to us that he was planning to BASE jump off a desolate antenna that stood two thousand feet from the ground! That's seven hundred fifty feet higher than the Empire State Building!

My dad is a pretty conservative guy, but when he heard this, it sparked a real interest, and he asked Brandon question after question about his escapades. My dad was fascinated with how Brandon lived his life, which baffled me since I would never think my dad could relate to someone who thrives on surfing, BASE jumping, and skydiving. Even after Brandon left, my dad couldn't stop talking about him and how much he admired his dedication to living a happy life.

Outside of experiencing life's adventures to their fullest potential, Brandon doesn't require very much. He'll be the first to tell you how expensive some of these adventures can be, but as long as his day job affords him enough to get by so that he can head out to tackle his next big conquest, then it's always worth the risk to him.

To me, the massive black battleship I tattooed on Brandon is a reflection of all of that. Sometimes when you are faced with something so powerful yet so beautiful, it's terrifying. Independence and freedom are more powerful than a great white shark or a battleship, and even more powerful than the ocean itself.

Brandon's lifestyle may appear very simple to those who don't know him. But in reality, he lives a very rich life. Free of society's judgments, Brandon has cultivated an independence that lets him live his dream—and that's something truly admirable. ✠

Camila
Rocha

At High Voltage, we have never hired a tattooer who was a complete stranger to our tightly knit circle—with the exception of Camila. Camila is an exception in many ways, really.

I remember the day when my sister brought her portfolio to me. Camila had mailed it to the shop, along with a letter humbly explaining that she didn't want to flatter herself in thinking that she could ever work at High Voltage, but her friends had talked her into sending the portfolio anyway to see what I thought of her work.

We get portfolios mailed to us on a pretty regular basis, sometimes filled with pages of quality tattoos. A lot of the time, we receive portfolios that are promising but are not at the high skill level I set for the guys at my shop. Regardless of the level of skill showcased in these artists' books, I'm always flattered that they would want to work with us.

At the time, my sister, Karoline, would usually filter through the portfolios and every now and then come to me with one that stood out in case I was interested. To be perfectly honest, although I would take the time to look through some of these portfolios, I would always have my mind made up that the person wouldn't have a shot, even before I'd open to the first page. The dynamic at the shop as it stands now is so special to me, and it's something I'm very protective of, so much so that the thought of bringing a stranger into our tattoo family frightens me, especially after having been forced by the network to "hire" casted people for *LA Ink*. We had all been firsthand witnesses to how much dysfunction certain personalities brought to our peaceful and creative environment, and those experiences had left us all a bit traumatized and wary of newcomers.

But, when Karoline came to me with Camila's portfolio, and said,

"I really think you might wanna see this," I got the feeling she was right.

Curious, I opened the leather-bound portfolio, and read the letter Camila had written. She had been tattooing at a shop in Brazil for years and was looking to grow artistically, and wondered if surrounding herself with the artists at High Voltage could be an option. Her humility and innocent spelling errors due to the language barrier were endearing to say the least, and by the time I flipped over the letter to closely inspect her work, I was shocked at how beautifully executed every single tattoo in her book was!

Camila's life changed the day she got her first tattoo. When she did, people she had known her whole life stopped looking her in the face.

"I know we don't ever bring strangers into our shop, but what about giving this girl a try? Maybe just a guest spot? For some reason I have a good feeling about this one," Karoline said.

My sis was right! I knew I'd be a fool to think twice about the idea of inviting this phenomenal artist here. I agreed to be open to a monthlong guest spot as long as the rest of my peers unanimously agreed, too. As I had predicted, every single tattooer at the shop was just as blown away and equally as excited to open our doors to Camila.

Camila came from Brazil with her husband, Mauricio. Not only was she sweet and humble, but far more talented than the dated photos of her work in the portfolio conveyed. That

month flew by so quickly, and in the end, no one on the crew wanted her to leave. She was one of us, and how often do we ever come across someone like that?

I offered Camila a permanent spot at the shop. It wasn't easy for her to leave the familiarity and comfort of the country where she was born, her friends and family, and the countless clients she had worked on during her tattoo career there. But having the guts to take that jump and try something new on your own—that independence is something I admire.

Having now spent several years here, Camila has become like a sister to me and to the rest of the team. When Camila asked me to tattoo her, I looked forward to it because every time I've worked on one of my fellow tattooers, the experience never fails to bring us closer. To me, this would be a small gift I could give her for everything she had gone through in order to be here.

Her idea for her tattoo was a large scale Japanese Noh mask. This would be her first tattoo on her left leg, and the plan was to cover a majority of her shin, starting at the base of her ankle and stretching all the way to the bottom of her knee. The idea of a Noh mask was perfect for Camila, considering that these traditional Japanese theater masks represent femininity and beauty. Noh theater dates from the fourteenth century, a time when women were subservient, and only men could perform onstage. The Noh masks were worn by male performers when playing female characters.

The mask Camila chose for her tattoo represented a female of her own age, a woman in her twenties. She was drawn to the image because of its feminine qualities, and because it reminded her of how traditional concepts of outward beauty shape our perceptions of who we are. In a city like Los Angeles, self-expression is everywhere. The way people dress, the way they do their hair,

the tattoos they choose—beauty is what we decide it is.

In Brazil, beauty is more commonly an expression of tradition, not personality. Societal standards can be strict and unforgiving, and being "pretty" is about having a perfect body, a perfect manicure, and perfect skin. Plastic surgery to become more beautiful is an accepted practice—but tattoos, especially large tattoos, and especially on women, are considered scandalous.

Camila's large-scale tattoo on her leg uses an emblem of traditional Japanese beauty to turn the ideas of feminine beauty from her own time and country upside down. For Camila, the Noh mask is a symbol of independence and self-creation. Camilla's Noh mask is about embracing her own definition of beauty and success instead of accepting other people's definitions of those things.

While I tattooed her, Camila told me that in the little town where she grew up, her father and grandfather were pastors in the local church and well-known local figures. Everyone knew her family, and she felt constant pressure to bow to traditional ideals.

"I didn't want to stay there for the rest of my life," she said. "I really wanted to go and travel and see the world. I had that vision for myself."

Camila's life changed the day she got her first tattoo. When she did, people she had known her whole life stopped looking her in the face. Her relationship with her family was altered. That external emblem of her inner self set the stage for her to move forward and create a new life more in keeping with who she really is.

So many people have big dreams, but rarely act on them. I absolutely love that Camila knows how important it is to pay attention to her dreams and risk everything to make them come true. This tiny, beautiful force of nature is one of the most inspired, inspiring people I know. ✛

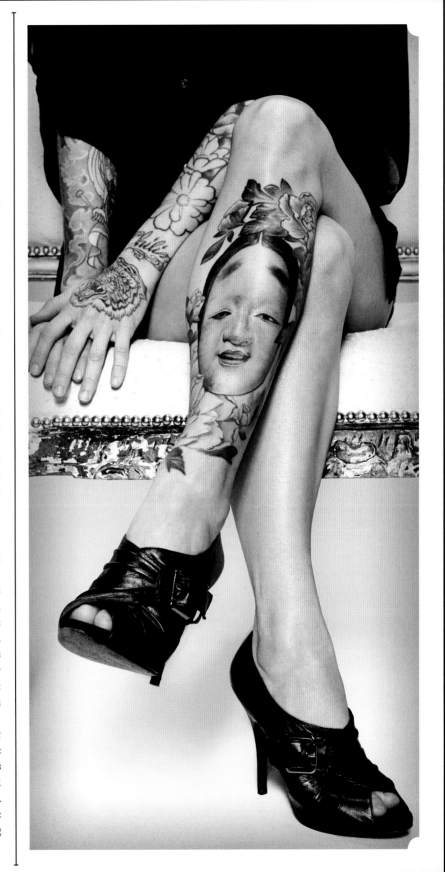

Ewan McGregor

When Ewan decided to get his first tattoo, the idea had been to incorporate into the piece things about him that were never going to change: where he was from, and his love for his wife and children.

Elements of the actor's Scottish roots are clearly represented in his tattoo. The dagger, otherwise known as a dirk (a long thrusting dagger that's the traditional and ceremonial sidearm of the officers of the Scottish Highland regiments), is embellished with a thistle, Scotland's national flower.

A symbol of love, the heart centered on his upper arm is pierced by the dirk, while scrollwork displays the names of his wife and kids. At the time, he had been sober for a little less than two years and was feeling like he had returned to his true self, a feeling I am all too familiar with. I also experienced feelings of welcoming back my true self once I got sober. When I look back at myself during my days of drinking and partying, it's like looking into the face of a complete stranger. I don't relate to that person anymore, and the person I am now is so far from the dysfunctional being I was then. My life is clearer, and the things I experience are far more profound—and memorable—than I ever imagined they could be. Those feelings of return and those acts of positive change are definitely worth celebrating and acknowledging.

Ewan didn't plan for the tattoo to be as large as it is. The drawing he had brought to Baby Ray, a Los Angeles–based tattooer, was much smaller, but regardless of its final size, the emotional impact was there. His virgin skin was permanently marked with art that represented the most important things in his life, his wife, Eve, and their three daughters. When Ewan and Eve eventually added a fourth little girl to their family, he wanted to add her name to his tattoo.

When Ewan contacted me about getting tattooed, he complimented some of the black and gray roses he had seen in my work. Always more than delighted to tattoo roses, I was excited to see what he wanted to get.

Anytime I'm required to work around or with a preexisting tattoo, I like to graph out the space that is available during the consultation. During that first flow of idea exchange, I can usually get a vibe as to what the person is looking for artistically and how they might personally connect to the tattoo.

Carefully tracing out Ewan's arm, I mapped out the spaces we were left with. The goal was to add a new banner at the top of the piece, with his youngest daughter's name spelled out in cursive. Knowing how important it would be to blend the new tattoo with the existing one, we talked about ways to execute it that wouldn't make the tattoo look cluttered or take away from it. The softness of fine-line black and gray roses was a perfect answer to a background, especially because the tattoo itself was already so bold. The contrast between the grays and the bold colors in the heart and in the thistle complement each other nicely.

"It just felt like I hit the ground running because I was meant to be there; I was ready. I didn't ever question anything career-wise because I just did exactly what I wanted to do. This sort of arrogance was not negative, and it made me who I was."

—Ewan McGregor

Not only do I love that a simple natural element like roses made these various elements blend seamlessly into one piece, I also love their symbolic meaning to Ewan: the five roses represent the most important women in his life.

All in all, it was a treat to work on this tattoo. I was able to not only add a freshness to his piece, but also to amp up the vibrancy and contrast of the colors. I added shading and depth to certain aspects of the tattoo to make it appear as if it had all been done in one fluid shot.

Collaborating with people like Ewan is artistically satisfying. He trusted my input and let me be as creative as I could possibly want. Because he's an actor, the only thing I had to be conscious of while tattooing was to make sure the tattoo didn't go much lower on his arm than it already was. Concealing a large tattoo during long periods of time filming a movie is a job of constant upkeep, and tattoos that are harder to hide can become vexing.

It was fascinating to listen to Ewan's perspective on life and work—I love to meet people who are passionate about what they do and how they do it. "I was extraordinarily arrogant when I was younger," he told me. "It just felt like I hit the ground running because I was meant to be there; I was ready. I didn't ever question anything career-wise because I just did exactly what I wanted to do. This sort of arrogance was not negative, and it made me who I was."

Working mainly in independent films, with the occasional foray into the world of bigger-budget studio productions, Ewan has always approached his career with clear intent, making well-considered choices about the films he's in and the roles he takes on. He's had the luxury of not having to answer to anyone in terms of his work; he can read through the scripts that agents send and decide what he

wants to do. Most of the time, that means he chooses to be a part of independent films—which are more satisfying creatively for him than they are lucrative—because they're not about box-office sales and earning back investments. They're about art and tackling the offbeat or even controversial subjects with greater scope and depth. Ewan says he's enjoyed the studio movies he's made, but as an artist, I can understand how much more fulfilling it is for him to be involved with independent moviemaking, and for that, I admire him even more. ✠

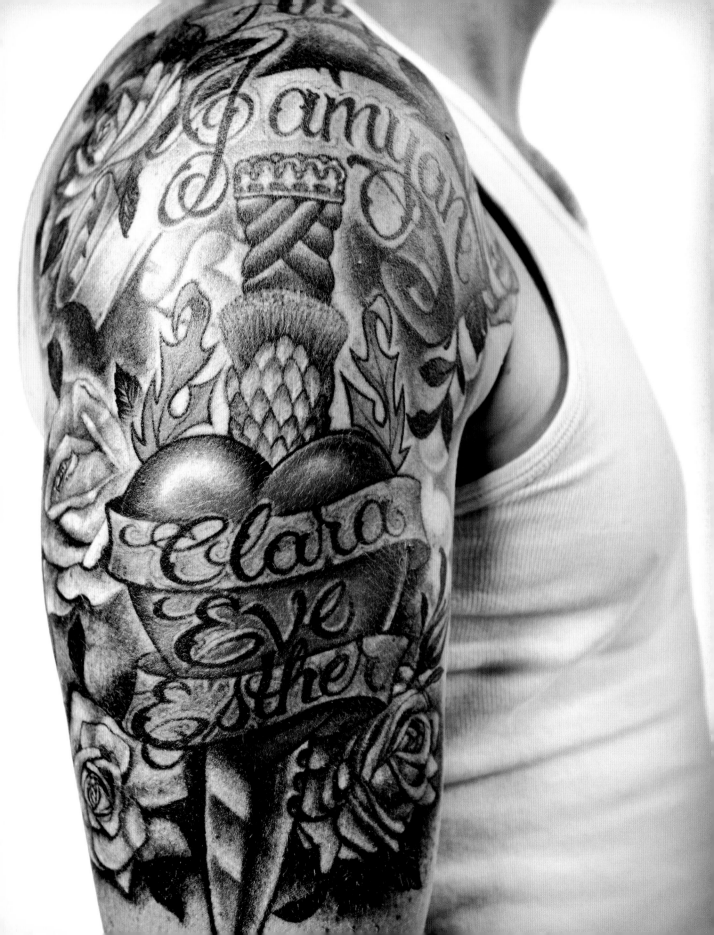

2010

ike all people, I've suffered from lovesickness and tasted the pain of love. The theatrical director of my mind, the one who staged all these visions of him and my life with him, seemed to be unaffected by reason. I was finding myself constantly daydreaming of the past.

His eyes, his hands, his crooked smile—I'd ruminate over his features. Things he said. Things he did. Things he wrote. Things he drew. Things he sang. Over and over again, I'd sift through these images and memories as if they somehow contained the answers to my prayers. But I was living with a long-ago memory of him; living so far away from the present moment.

If we had spoken about what we were or what we thought we were, back when we got sober, I wouldn't have been so confused, wondering what if, and writing the rest of our story in my mind. What did I expect? For him to magically not hear about me being in relationships? And to not be bothered by it?

If only he would have asked . . . I would have. . . . If we could have only talked . . . then things would be. . . . If we allowed ourselves to transcend our fears of being open, vulnerable, then, I'd convince myself, we would be together.

I realized that none of that mattered now.

If I wanted to be free of this unrequited longing, I would have to make peace with the past and finally let it go. There was no way around it. But did I want to be free of it—and him?

PRESENCE

"Confine yourself to the present."

—Marcus Aurelius, MEDITATIONS, AD 167

I will never forget waking up that morning to the frantic buzz of my cell phone. There must have been twenty messages from my friend Doug, who had been staying at my house for a few days to keep an eye on my sweet five-month-old kitten, Valentine, while I was away. I was halfway through my book tour, and the signing the night before left me too exhausted to drive home, so I had chosen to stay in a hotel near the bookstore.

Confused and curious, I dialed Doug, who answered in a tone of hesitance and gloom.

"I don't know how to tell you this, Kat, but something really terrible happened last night."

Taking a breath of preparation for the worst imaginable, I responded, "Okay."

"The Castle burned down last night," he said. My first thoughts quickly went to my kitten. The idea of her tiny innocent body hurting struck to the core of my being.

"What about Valentine?"

"She didn't make it, Kat."

I took one more deep breath before I simultaneously thanked and apologized to Doug for having

to deal with something so tragic as this. Looking back at that moment now, my heart goes out to him for having to bear such bad news.

From what Doug described, I understood that the fire had started sometime between eleven P.M. and midnight, burning slowly until the firefighters arrived. By then it was too late. They battled to extinguish the fire until dawn, but in the end, the majority of the house was demolished by flames. Doug struggled with his words while he told me what had happened, so I knew it was bad. It had to be, if even Doug, whom I knew to be fearless, couldn't bear to describe the extent of the damage to me.

My reaction was to remain calm. I wasn't feeling aloof or cold or disconnected. Perhaps it was because of my daily meditation that I found strength in remaining calm, but I knew that the sooner I accepted those things that were out of my control, the easier this would be to deal with.

Somehow I was able to discern that this terrible event was somehow part of a bigger picture. Except for the loss of Valentine, the belongings I had accumulated throughout my life and neatly archived throughout the Castle—books and pianos, photos and clothing—were lovely to admire, but they were still just things. They had monetary worth, of course, but to me, they just held sentimental value. Like memories, these objects were a part of my history, but they didn't define me. When I broke it down, ownership was just a mentally generated impression. It wasn't real, unlike the feeling of love or nature.

When I drove back to LA in the early morning and approached what was left of my home, I puzzled over what I should do. I had another book signing in Canada, and my flight was set for later that afternoon. As confused as I

was, something told me I would be foolish to cancel the rest of the tour. Somehow going back on the road and engulfing myself in the arms of the fans that knew nothing of what had taken place was where I was meant to be. Staying in LA and sulking about this loss would only make things worse.

Nearing the exit off the freeway to the Castle, I felt the urge to stop the car. I pulled off the road, parking at the bottom of the hill below the house; closing my eyes and breathing were the only things that felt right. I didn't have the courage to see what had happened with my own eyes yet.

I decided to call my assistant, Kat McPhee, who had only been with me a week at the time. I told her what had happened as concisely as I could. She gasped. Setting aside my pride, I explained that I was parked on

With every step we took toward the house, it felt more and more as if we were approaching a funeral.

the side of the street and that I didn't think I was strong enough at this moment to actually go and see the house.

"Would it be okay if maybe you could go there first and tell me how bad it is?" I asked.

Without hesitation, McPhee came to the rescue. I drove to High Voltage and awaited her report with Doug, who still hadn't slept.

After McPhee's examination of the Castle, we met next door at Wonderland. Surprising even myself with my composure, I calmly digested her description of the destruction. This all was indeed very real, but I didn't want to dwell on it. We were all quiet for a moment. A natural leader, McPhee took charge. "Okay," she said. "What's the next step?"

I knew I had to go and see whatever was left of the Castle myself. As McPhee and I pulled up to the

property, the first thing that hit us was the overwhelming campfire smell. With every step we took toward the house, it felt more and more as if we were approaching a funeral. There was no need to look for a key to the front door, since the once solid structure that had been my home was now vulnerable and open to the sky.

Proceeding with caution, McPhee and I hardly said a word as I took it all in. Each room seemed to show more damage than the one before it. Dark black silhouettes of what used to be my collection of taxidermy lay amidst the rubble in the hallways.

Seeing this triggered all the memories that had been created in this space. This was my home. Not my house, my home. My safe haven. Everything had been in its right place the last time I stepped out the door. The kitchen table where I had spent hours drawing, writing, painting. The room where I kept my guitars. My pianos.

How strange it felt to process this.

Seeing everything this way, feeling everything this way, wasn't nearly as difficult as trying to breathe. The smell of smoldering ash was just as dense as the smell of death, yet we treaded through the debris, following the path of wreckage to what once was my warm and welcoming living room. Blackness. That was all that was left.

I felt comfort in accepting things as they were.... I was more in control of my emotions, more patient with whatever life handed down to me.

McPhee and I spent only a few more minutes exploring the ruins before we returned to the car and drove back to Wonderland. It's at this point that my memory fails. I don't remember pulling away from the Castle at all, and I can't for the life of me recall the drive back down the hill.

At the shop, we all agreed it best to move forward with the tour, and somehow it made me feel even stronger to just keep going. I owe everything to the support of people like McPhee and Doug. Like I said, I had only known McPhee for a week at that point, but having her there made it impossible for me to give up. When the going got tough, my friends got tougher.

The true challenges came down to different things: dealing with the physical realm and the mental realm of the situation. I had read a lot about this in Eckhart Tolle's books and listened to enough of his lectures on this book tour to understand the difference between the two, and it was the latter that was the hardest for me.

The physical realm encompasses all things corporal. Where will I sleep? Where do I shower? Where do I start? What about amenities? Underwear? Warm clothing?

The mental realm asks the emotional questions. What will people think? Does losing everything I

once had make me less than? How could this happen? How do I tell my family? My friends? And the worst of all questions: Why me?

Feeling sorry for myself didn't seem like the wisest route in this situation. I really can't explain it, but I seemed to make peace with loss and handle it calmly. I was proud of myself for not being attached to all of my things, although I knew I would miss some of them. Going back out on the road seemed like the best option.

I was heartbroken about losing Valentine, that was for certain.

Losing Valentine made it almost impossible to not think about when my cat Ludwig died. Man! I was a wreck back then. I couldn't work. I couldn't talk about it without losing control of my emotions—I wept for hours on end. I had never experienced loss like that before. It took a lot of grieving to get past it.

But now, although I was sad about Valentine, I felt comfort in accepting things as they were. Ludwig had died only a year before Valentine—how could I react so differently? The only thing I could determine was that I was more in control of my emotions, more patient with whatever life handed down to me, more accepting, and finding joy in all the little moments, as opposed to feeling sad about the past or worrying about the future.

I was more present. And for that, I am proud of myself. I could see that I had grown.

My reaction to the Castle burning down was proof to myself that I was heading toward finding inner peace. I felt strong, almost bulletproof. I felt safe knowing that no matter what happened to me or around me, nothing could take my peace away, unless I allowed it to.

Instead of weeping to my friends and family about what a victim of bad luck I was, I felt grateful for them and what I did have. Instead of seeking a false peace through blame, I found strength in my own resilience.

Even today, no one really knows for certain what the cause of the fire was. The city fire department ruled out the possibility of arson, and although most clues lead to a possible electrical fire in the walls downstairs, the inspectors' investigation was inconclusive. Personally, I blame it on the full moon. And I say that with a light heart because at the end of the day whatever happened happened, and except for Valentine's fate, there is nothing about the fire that I would choose to change today.

That morning, there was a lot to do. Practical things had to be attended to. I had to contact my business manager and the insurance companies, begin to compile some sort of inventory of what was lost, and explore living options for when I'd return from my book tour.

First and foremost, we had to find my passport, if it even still existed!

I could not have managed any of this without McPhee. She is the definitive hero of this story. She tried her best to make it as easy as could be for me to get back to the book signings and feel up and present for my fans. While I set up camp at the shop, she went back to the Castle to look for the passport, and she was all smiles when she returned, waving the half-burned passport like it was a golden ticket that gave her entry to Willy Wonka's chocolate factory.

At that point, we laughed out loud. Finding that damn passport felt like Christmas! Suddenly, all these little random knickknacks, like my iPod and headphones, or the sweater that I had at one time carelessly left in my car, became great gifts. That morning, going to the mall to shop for underwear and the basic amenities that I'd need for the remainder of my trip was full of merriment. We made fun of the fact that I was driving a fancy car, but was technically homeless. Stepping outside of myself made it easy to see the humor in it all, and that was proof in itself that life goes on.

When I think about the many ways things could have ended up, I was very well the luckiest gal on the planet. If I had made the trek back to the Castle after my book signing the night before, I would have gone to bed before the fire started and

slept through the smoke, because the fire alarm, which was supposed to instantly trigger a call to the fire department, malfunctioned—and we never found out why. It's pointless to spend that much time thinking about all of the "what ifs," but it is clear how situations like these serve as powerful pointers to the ultimate truth: Every day is a gift. Every moment, good or bad. Even if you wake up to learn that, as Buddha said, "in order to gain everything, you must lose everything."

Meghan Luce

"Take me,
I am the drug;
take me, I am
hallucinogenic."

—SALVADOR DALÍ
Dalí by Dalí, 1970

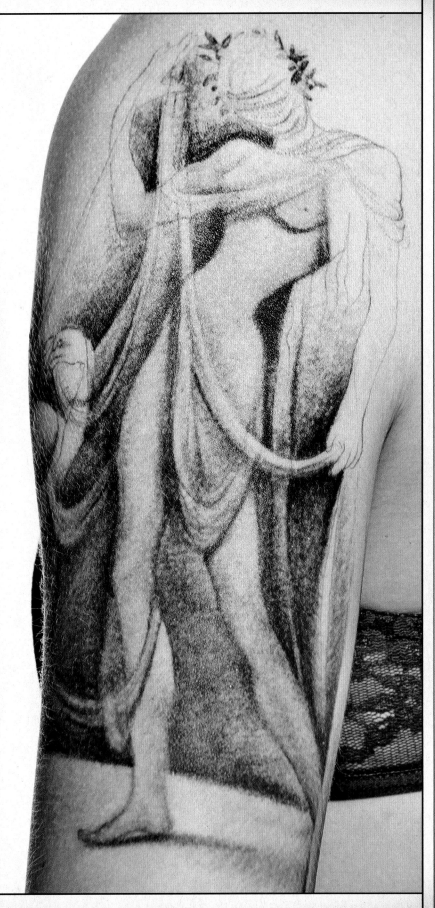

ike Meghan, I have been a longtime fan of the work of Salvador Dalí. His art inspires me, as does his approach to life, love, and art. Freeing himself from the backlash of opinion, Dalí expressed himself fearlessly in an unconventional—and sometimes even defiant—manner that often wasn't received all too well by critics or even other artists. Never limiting himself to a particular style or medium, Dalí continued to evolve as an artist until his dying day. Anyone who says "you can't do everything" is obviously not familiar with the invincible spirit that is Salvador Dalí.

During my years of tattooing, I've been lucky enough to tattoo renditions of his works, quotes he was known for, and portraits of the artist himself.

Meghan scored major cool points with me when she explained her idea for her sleeve—a compilation of several of Dalí's pieces and a portion of a sketch he had done in the 1940s. Because of the flowing nature of most of Dalí's art, I could easily see how to merge these pieces into a single seamless one, and through that be able to tell a story.

The portion of the tattoo Meghan chose for her upper arm, of mummy-like dancing figures, was her homage to the world of dance. Dalí had always been a fan of ballet, and drew many pieces that were inspired by it. Meghan chose these "dead" dancing figures as a focal point in her tattoo because her dance career had been cut short. Just as tattooing was my first love, dance was Meghan's. As she grew up, ballet was a consistent friend she could turn to at any time. But at eighteen, she badly injured her left knee while doing a grand jeté and was forced to stop dancing.

As sad as her story sounded, it was moving to listen to Meghan talk about how those dancing years motivate her

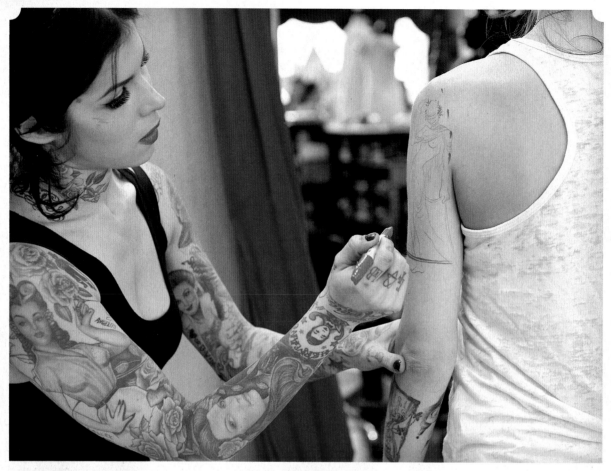

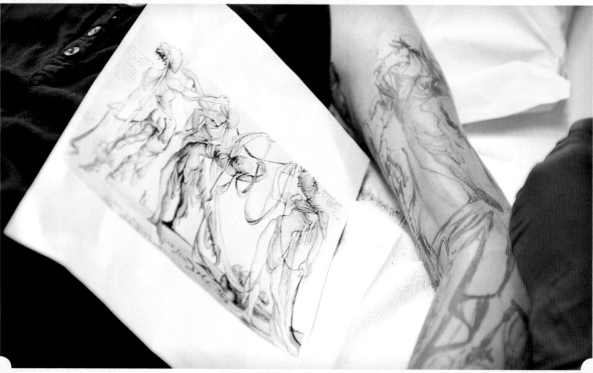

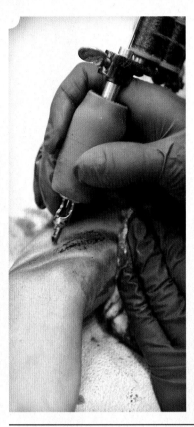

even now. Growing up, she didn't have much structure. An absent father and a somewhat weak relationship with her mother left Meghan seeking outlets to channel her energy and feel part of something bigger than herself. Dance became the answer. She loved ballet for the structure, and she loved dance for the feeling of freedom it gave her. The beautiful thing about dance for Meghan was that although it was something she could perform on her own, she also had the support of her teachers and peers.

Toward the end of the conversation, Meghan said something that struck a chord with me. She told me that even though she has always marched to the beat of her own drum and made independent choices, over the past two years she has learned how to do so with confidence. Believing in herself was something new, and it was as if she was able to see beyond the challenges in her past

and not let them fully undermine her. The disconnection that came from not knowing her father; the insecurity that emerged from not having a healthy relationship with her mother; these experiences had once left Meghan feeling like she didn't know who she was or where she came from. She is working through those barriers now, but this is something that she says she sometimes still struggles with.

Your true self can never be found within anyone else, and it cannot be found in the hardships that life has thrust on you in the past. Whoever you think you are, or whomever you want to be pales in comparison with who you truly are, right now, right at this very moment. While we talked, all I could think about was that I loved the Meghan I saw before me. I love her the way she is, independent from her past and fully embracing her life as it is now. ✛

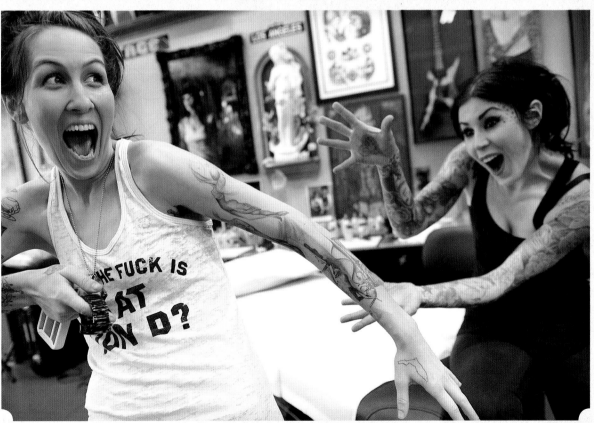

ven as I was mapping out Linda's back piece, in my mind, I scolded myself for not thinking of this idea first for a tattoo for myself! "My Beloved"—a perfect combination of words. There was no better person to get it other than Linda, though. She is blessed and cursed with being romantically charged. I've never met anyone who so openly wears her heart on her sleeve.

I asked Linda why she wanted these words tattooed, and why it was so important to have the tattoo take up such a large portion of her back. As it is for me, love is a higher power for Linda, and this tattoo is a representation of that. Her idea of love isn't much different from mine, and to listen to her tell me what true love is was like listening to my own heart say all the things I always wanted to express, but could never find the right words. She said:

Tattooing Linda is special for me. The tattoo was a gift from me to her, and it was the least I could do to repay her for all the amazing ways she's affected my life. Since the words would stretch across her entire upper back, they had to fit her body perfectly. After an hour into the drawing itself, I realized that the most challenging part of this tattoo would be laying out the scripted letters in a way that would fill the space properly without stifling the flow of the letters.

Linda and I have a special relationship—over the years, she's become one of my closest friends. I never told her this in full detail, but before I met her, I was on a flight somewhere, flipping through the airline magazine that's always found in the seat pocket in front of you. Lo and behold, there was a photo of this beautiful, strong woman. Sure, I noticed the collection

of tattoos she had all over her arms and hands, but they weren't what caught my attention. Something else about her made me feel connected to her, and I somehow knew we would be in each other's lives.

I was so sure of my premonition that I tore out the page with her interview, and took it home with me to show my sister, and share these feelings with her. I knew Karoline would understand. When I showed her the photo and told her what I had thought when I had first seen it, Karoline's eyes grew wide: while I had been away on my trip, Linda had reached out to make an appointment to get tattooed by me.

Just as I had predicted, Linda and I quickly became close after meeting at her first tattoo session. Conversation flowed so easily, and one would have assumed we'd known each other since childhood. She wanted to get an image of a stylized geisha girl on the inside of her bicep. The imagery was taken from the massive mural at Kung Fu Gardens, her recording studio, not too far from where I live. On a wall overlooking the main recording room, the hand-painted image of the geisha girl watches over Linda as she creates her music.

I was amazed to have finally met someone who was just as much a romantic as I am. But hearing her talk about how she pours her heart and soul completely into all that she creates—every song and every lyric— that's what I most loved about Linda.

Although this was a new friendship, I was very aware, as most people are, of Linda's accomplishments in the music world, not just for her own music, but for the many projects she has produced, written, and orchestrated. As much as we talked about music during our tattoo session that day, I was far too shy to bring up my recent interest in singing. At the time, I had just started taking voice lessons and was trying to keep my plans for making music somewhat private.

"True love is rarely felt. It's a warm hum that settles inside your heart. Even when she is not there, I feel the embrace of her love—caring, gentle, honest. It's not forever; it's eternity. It's never letting go of that love even after they are long gone. Closing your eyes and being able to see that person in every scenario knowing they just fit. True love is giving space however long needed, knowing that they will always return.

Insecurity doesn't exist because the trust is so strong. Being inspired to live, when you'd rather die. Changing not because you need to, but because it will make you better. Excited to get home and share the most juvenile experiences, like how you got the last pair of glitter heart-shaped glasses and then turned around and gave them to the little girl who wanted them more.

True love is knowing that this person can make you feel everything you ever imagined and romanticized. Knowing that they get you especially when everyone else doesn't. Growing together. It's believing with all my heart that if I die today I will be returned to you in another life."

It wasn't until months down the road into my vocal lessons that I started gaining a little bit of confidence in my ability to sing, and it wasn't until that point that I felt comfortable confiding in Linda what I had been secretly doing. One night over dinner, I mentioned the vocal lessons to her, and with a child-like excitement, Linda shot off an arsenal of questions, one right after another.

"Where are you with the singing? What's your vocal range? What does your vocal coach think about your voice? What do you sound like? When can I hear it?!"

Before I could even begin to answer any of her questions, she asked, "When are we recording?"

I honestly assumed she was joking at that point, and I'm pretty sure I was blushing out of self-consciousness. Discrediting my ability to sing at the time, I brushed off that last question. It was more than a year later when Linda and I started trying to record together.

The first few times I went to Kung Fu Gardens to work on music with Linda, I completely choked. Even though I very well knew I could sing the song and hit the notes, something went haywire in my brain. In a half millisecond I shut down. I wanted to sing so badly in front of her, but as hard as I tried, nothing came out. My stage fright shocked even me. All I wanted to do at that moment was disappear. Over the years I've become so deeply familiar with tattooing that it's become second nature. But music was different. Listening to music and making music were two distinct activities, and the part of me that fears failure in singing gets kicked into overdrive. I have so much respect and love for music itself that it's hard for me to settle for anything less than excellence. I know part of the risk of taking up a new thing is making the commitment to it, whether you fail or not. But with music, I was completely terrified of failing.

Linda would always tell me, "You can't be scared of imperfection. And you can't edit raw emotions, because you'll never perfect them, because you're not supposed to."

After the third time of showing up and choking, I contemplated giving up on singing altogether. Defeated and frustrated with myself, I drove back home in silence, too angry with the disappointment of that day to turn on music in the car.

I knew I had to work through whatever was standing in my own way. I had to figure out a way to get outside my head and away from these negative thoughts and fears that kept me from singing out loud.

Lucky for me, Linda never gave up on me. She was familiar with the feelings I was experiencing and really helped me through them, but most of all, she believed in me. ⚜

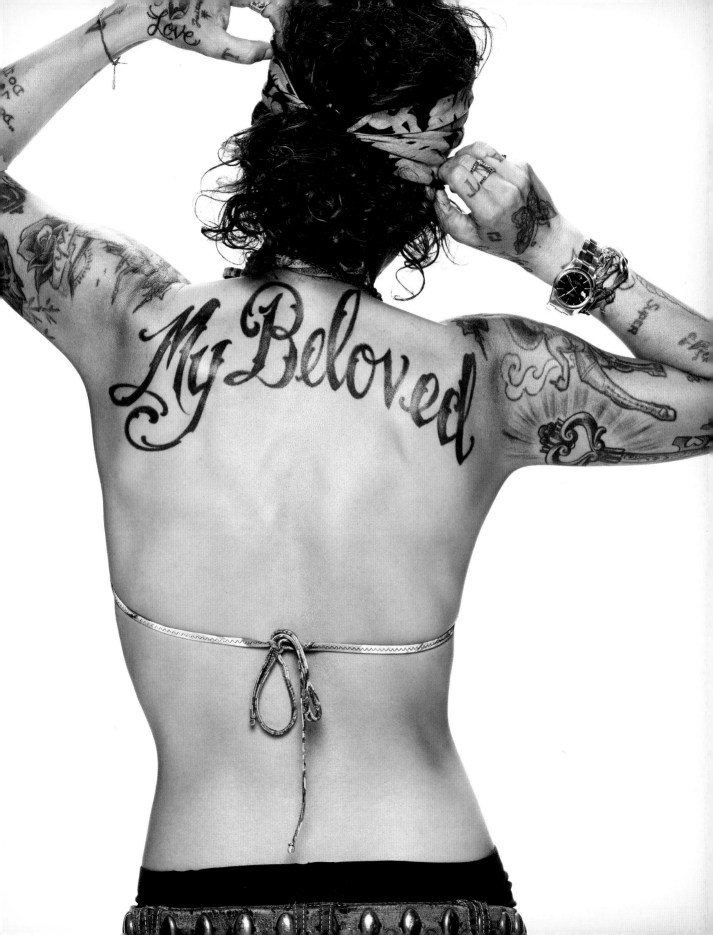

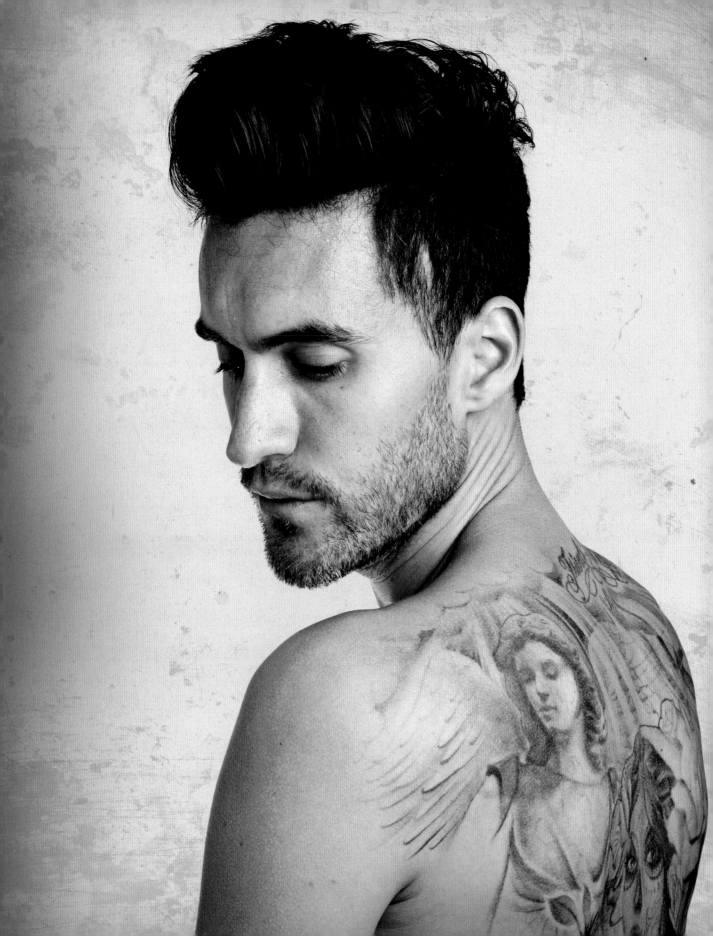

Felix Rodriguez

I was a fan of the Sounds, a Swedish band, for a while before I got to meet Felix, the guitarist. We eventually connected through mutual friends, and soon after that, when the Sounds were on tour in Los Angeles, Felix carved out the time to come into the shop and get tattooed. His black and gray piece was inspired by a Day of the Dead theme: a beautiful woman's face, fully rendered in Day of the Dead makeup and framed with intricate lace, took center stage on Felix's back. Below her a number of skeletons wearing traditional mariachi outfits, complete with sombreros, played music. Shading and black and gray roses tied the woman and band imagery together smoothly.

A fan of this style of Mexican art, Felix thought that combining the two images celebrated his passion for his music. Looking at the collection of tattoos he already had, I could see a pattern: all of his pieces were fine-line black and gray, with a heavy influence of the Mexican art culture that is so prominent in Los Angeles. He had tattoos of praying hands on his chest, Old English lettering across his stomach, and fine-line script at the base of his neck.

We were able to knock out a majority of his back piece in the initial first two sessions, mainly because we had to. I usually don't like tattooing people for more than two to three hours. After those first few hours under the needle, the body's natural endorphins tend to wear off, and the client is usually left to struggle

through a lot of pain, so spacing out hours of tattooing has always seemed to work best. But in Felix's case, we wanted to take advantage of his time here in the States before he went back on the road.

A year passed between doing that tattoo and our next session, although by this time we had become close friends; I had visited him during the year in Sweden, where we had talked about working on music together. Now the Sounds were back in the States on another tour, and Felix came to see me with the idea of adding more to his tattoo. He wanted to add an angel hovering above the existing piece, and the references he provided, photos of beautiful statues taken in a cemetery, were perfect for that addition.

Instead of cutting and pasting the references Felix had sent me prior to his arrival, I thought it best to take the essence of those images and create an original piece—one that connected aesthetically to what we had already completed, using the texture of shading in the clouds, the rays of light, and smooth black and gray gradations to join all the elements.

During that session, we added the angel above, and talked more seriously about the idea of working together on some music. Since he was going to be in LA for a while, we carved out a week's worth of time to diligently work on writing and recording.

While he was on the road in Dubai, Felix had developed a passion for surfing and he was eager to get into the Pacific with his board while he was in town. He invited me to join him, and I agreed. I had surfed only once before, with Brandon Lillard (see page 114), but my huge fear of sharks had prevented me from keeping up with it. Felix's passion inspired me, though, and since I had a wetsuit hanging in the closet and an eager teacher, I agreed. I thought that getting in the water, like I did with Brandon, would help me conquer my fear of sharks; and I thought that learning to enjoy the ocean would be another way to practice embracing being fully in the moment.

I had been working on being present and not concentrating on my fears when it came to singing. I was so desperate to shake this fear that I even went to a hypnotherapist. At first, I believed that the hypnotherapy had worked—at least for the first few hours. But I soon discovered that it only took the mere thought of having to open my mouth in front of Linda to shut me down. Too embarrassed to return to the hypnotherapist after the third time of not getting anywhere in overcoming my fear, I sheepishly gave up on the whole process.

But I couldn't give up on my vision to sing. There is just something

inside me that needs to express itself through music. I hoped getting back into the water would trigger something in me that would help me relax and be free, be in the moment. I wanted so badly to just do things like I used to be able to, like when I was a kid and I didn't care what anybody thought.

Felix and I tried going surfing every morning before our writing sessions. There would be moments when we were out in the water when something would brush up against my foot, maybe a plant or something, and I would instantly revert to fear and paranoia, imagining a dinosaur-sized great white shark in the water underneath me. Then I would relax, shaking the feelings off so I could enjoy the waves, the sun, and the blue of the water. Each time I paddled out, I felt more confident, until I managed to stand up on that board. It was just for a second, but I did it!

It helped me see that the only way to be truly present is to embrace every aspect of the moment that I am in, both the excitement and the nervousness. When I tattoo, energy buzzes around me—a current of people, music, talk, and laughter. Focused on skin cells, on the needle, and on the sound of my tattoo machine humming its own little mantra, I completely lose my sense of time. I am absolutely present. Seriously, the entire shop could be flying away in a tornado, or sinking into quicksand, and I'd still be nowhere else but here. In a world of fuzzy noise, multitasking, constant glancing at cell phone screens, tweeting, and e-mailing, tattooing gives me a sense of quiet and peace. It's beautiful. ✢

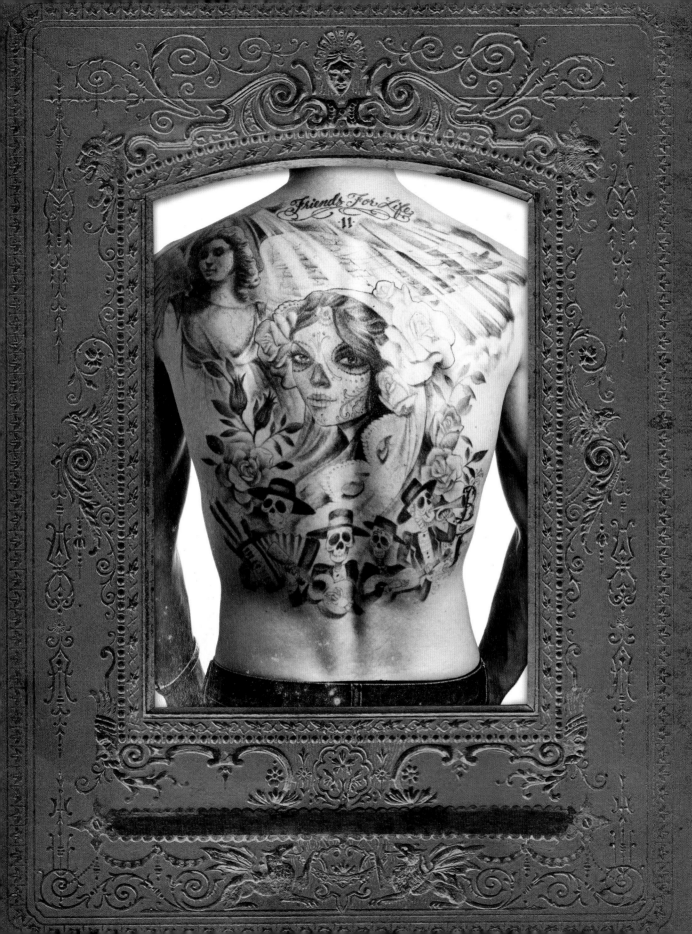

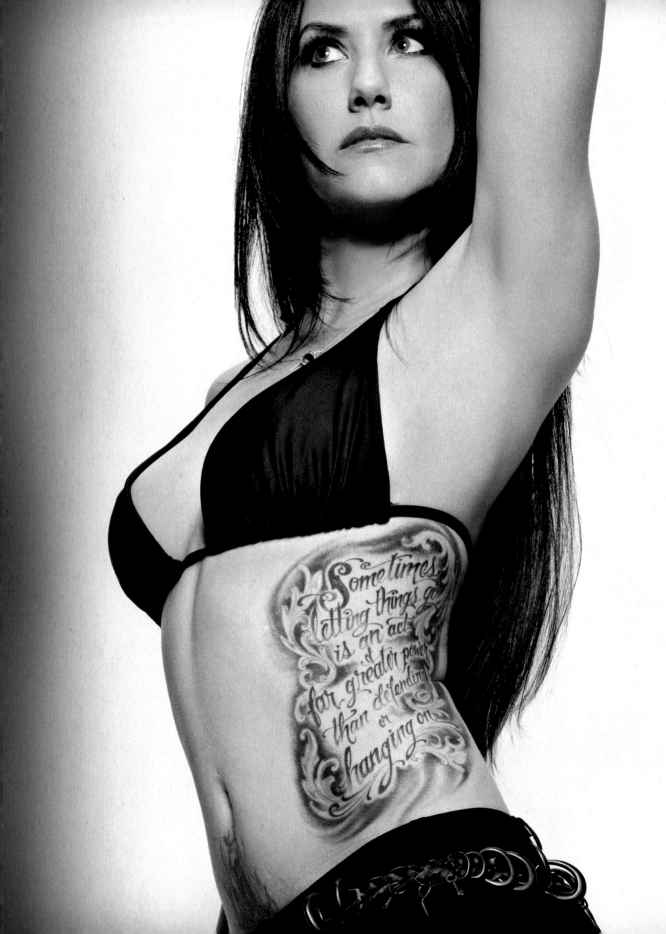

KRISTEN MULDERIG

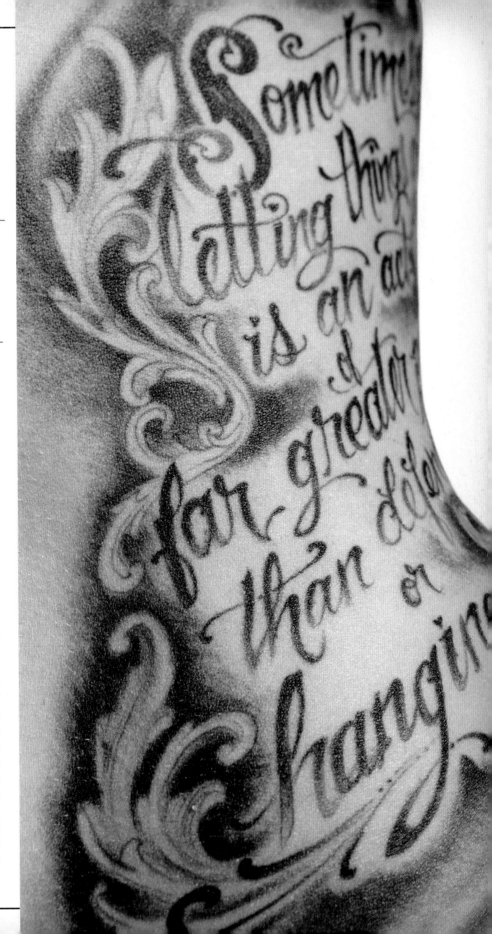

"Sometimes letting things go is an act of far greater power than defending or hanging on."

—Eckhart Tolle, *A New Earth: Awakening to Your Life's Purpose*, 2005

I was thrilled when Kristen presented the idea of getting this Eckhart Tolle quote tattooed on her ribs, not only because of the beautiful message, but also because of the great impact Tolle's teachings have had on my own life.

I could easily have my entire body covered in quotes from his books or lectures. Heaven knows I've jotted hundreds of them down into the little notepads I carry around in my bag every day. His teachings have helped me understand and see life in a clearer way. They are pointers to truth.

I wondered why out of all the things Tolle has said, Kristen gravitated toward this particular quote. Her explanation was simple: it resonated with her because it pertained to her own struggles to let go of the things that are out of her control. But the act of letting things go, accepting things as they are, and not feeling like you need more than you have are challenges for almost everyone I've ever met, myself included.

Holding on to memories keeps me in the past, and looking backward makes it harder to appreciate the here and now. ⚜

2011

 listened to one of his songs the other day. Out of all of the songs he wrote on that album, this one was the most direct. He sings my name in the chorus. By the time the song is over, I've felt a range of emotions—I'm sad but happy, frustrated but calm. 5

He sings about how I alone bring him to a place of stillness and peace within when we are together. What a victorious feeling—to enter into a place with him where no one else has been. To be able to 10 bring goodness to and draw it out of someone. Those sweet thoughts were interrupted by an e-mail from him. Impeccable timing as always.

It's just a short note, letting me know that he's somewhere out there, 15 thinking of me. He ends the message by calling me "Star Face"— his pet name for me from long ago that no one else uses. At that moment, I loathe him for it. I loathe him because I love him.

Sometimes it feels like it would be so much easier to walk away from 20 this if he'd just tell me that he hates me, that he wants nothing to do with me. But instead he calls me "Star Face." There is no way he doesn't know what he's doing. He's not letting it go, either.

"Those who know, don't lecture;
those who lecture, don't know."

—Lao-tzu, sixth century AD, China

Some of my greatest teachers have been my clients. They tell me their stories and invite me to look into their hearts. My friends are my teachers, too. Linda, Danny, my crew at the shop; I am constantly learning from each of them. On a spiritual level, aside from the many wisdom books I have read, George Falcon has been the most life-changing teacher I've ever had. For lack of a better description, George is a qigong master, a spiritual teacher who shares his profound understanding of the world to help people understand their true natures and reach their fullest potential. I attend his weekly Sunday lectures at my friend Brent's house. Brent had been meeting with George one-on-one for ages; he felt so inspired by him that he wanted to share all that he had learned with his close friends.

When I learned that George holds a meditation retreat at a monastery at the end of each year, and that Brent and a few of the other guys I see on Sundays had amazing experiences on those retreats, I signed up.

Before the retreat, instead of being calm, I was stressed. I worked frantically to get things together before it was time to go: finishing tattoos, wrapping up loose ends, managing deadlines. I had been informed that I would have no access to a phone, and the five days of lectures, fasting, and meditation were to be done in silence.

Spending five days living in a monastery about an hour south of Hollywood, high up on a hill, removed far enough from everything and everyone, was exactly what I needed. I'd be turning off the electrical leash that my cell phone has become over the years. I'd be completely unplugging from all the day-to-day noise of work, drama, and adversity, and plugging back into myself.

When the day came, I drove up the winding road toward the monastery and parked in the empty lot. I was the first to arrive, and Irma, the sweet nun who checked me in, confirmed this as she showed me around. Wild peacocks casually roamed the courtyard, and I felt the serene presence of nature all around me.

All the answers to all the questions I had been losing sleep over were there— and they always had been there.

She walked me through the building toward my quarters, and the view from the rooms was magnificent. Through the blanket of gray sky, I could make out the small, faint silhouettes of the buildings of downtown Los Angeles. They had been so massive when I drove past them on my way here, and now they appeared as tiny specks amid all the smog.

Room number nine. After unlocking the door, and showing me in, Irma handed me the key, letting me know if I needed anything more to simply ask.

What more could I possibly need?

"Thank you," I said, not realizing that would be the last exchange of words I would have for the next five days.

The simplicity of the room reminded me of the time I had spent living upstairs at Wonderland when my house had burned down. There was a small bed and a lamp. An illuminated crucifix hung on the plain brick background of the room, directly above the head of the bed.

It was seven A.M., and I had one hour to settle in before our first scheduled meditation at eight. I placed my suitcase on the bed and stood still. With my eyes shut, I took in the sounds around me. I could hear birds outside. The buzz of the heater. And then: the spaciousness

of the silence. Then I heard foot-steps outside my room, followed by Irma's voice as she led the others to their quarters.

I didn't know much about what to expect here, but I really didn't need to know. All I knew was what I'd been told to do: dress comfortably, bring an extra pillow or yoga mat—whatever I'd need to be relaxed. I changed my clothes and started to walk toward the meditation building. Without a phone, a laptop, a clock, or any other modern-day technology, my mind had plenty of space to take in my surroundings. I looked at the mas-sive tree outside my door. I noticed a black spider clinging to the center of its web, which was suspended between two green pine trees, patiently waiting for prey to fall into the meticulously woven net.

With nature all around me, I felt incredibly small in a beautiful way. There was an overwhelming feeling of sacredness, similar to the rever-ence I feel when I enter a church or temple, where the thought of ownership or titles ceases to exist. I belonged to these trees and the spider and the mountain air, not the other way around. I was part of nature's cycle, and I was only a tiny part of it. It's so easy to forget this when you're in the city. Here, the

brightness of neon was replaced by the glitter of the sun on a drop of water suspended on a spider's web.

The morning began with a med-itation, followed by a lecture and then a meditation exercise. Each hour concluded with a ten-minute break, during which I would stretch my legs by walk-ing and breathing the air outside. We had an hour break at noon and another at five P.M. In the evening, I would retreat to my room and write in my journal, then fall asleep. In this way, the days progressed.

Between the beauty of my sur-roundings, the meditations, and the separation from the frenzy of my daily life at home, I began to get in better touch with myself, my capa-bilities, my energy, my dreams, and my desires. All the answers to all the questions I had been losing sleep over were there—and they always had been there. If clarity is what I was after, then here it was, with me all along.

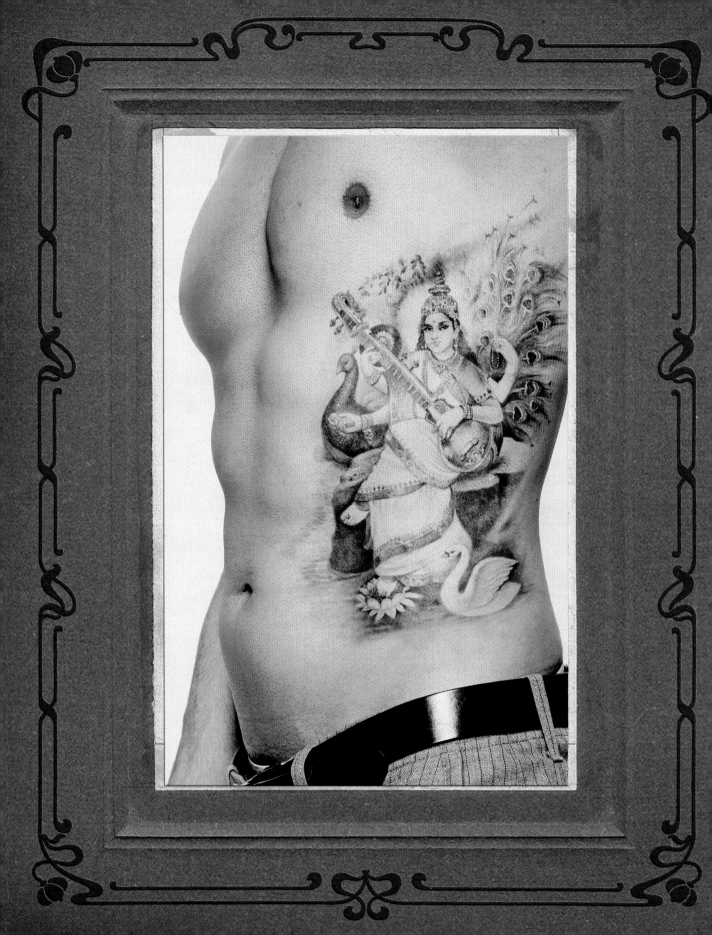

Prahbakar Kharre

Saraswati, better known as an Indian deity of wisdom, is the goddess of knowledge and art and the bestower of learning. She represents the free flow of wisdom and consciousness and is a prominent figure in Hindu iconography. Paintings of her often display a number of particular elements with profound symbolism, making every detail vital in Prahbakar's tattoo of her.

I don't think Prahbakar's initial vision for his tattoo was for it to be scaled this large, but after considering different images, we both agreed the tattoo would have to take up a large portion of his ribcage if we wanted to properly render the detail.

This tattoo was a representation of his mother, who prays to Saraswati, and whom Prahbakar looks to for support, compassion, and understanding. The inspiration behind the placement came from Prahbakar wanting to place the tattoo close to his heart in a place that was naturally protected. Listening to Prahbakar talk about the significance of this tattoo only made me more inspired to give it my all.

Representing the four aspects of human personality in learning—mind, intellect, alertness, and ego—Saraswati is always depicted with four hands. In one hand, she carries sacred scriptures, and in another a lotus flower, the symbol of true knowledge. With her other two hands she plays the music of love and life on a string instrument known as the *veena*.

Two elements of the image are portrayed in a saintly white: the fabric of her attire as well as a swan. Both are direct representations of purity. In order to achieve the look of lightness specifically in a black and gray tattoo, these elements would need to be framed with a contrasting background. My years of practice tattooing prominently black and gray images make it easy for me to translate vibrant color images to gray scale. The challenge is to remain mindful of the much-needed contrast.

Even though Saraswati herself was the main subject of this tattoo, the different textures and highlights of the image were the challenge. From a technical aspect, tattoos like these are some of my favorites to take on. I loved needling my way through the meticulous detail of the embroidered hem of the draped fabric and jeweled headdress, the pattern of feathers in the peacock's body and tail, visually creating layers through the shading of the leaves above her and water below, and capturing all the glimmering highlights throughout the entire piece. Elements like these are easy—and enjoyable—to get lost in during the tattoo process. ✢

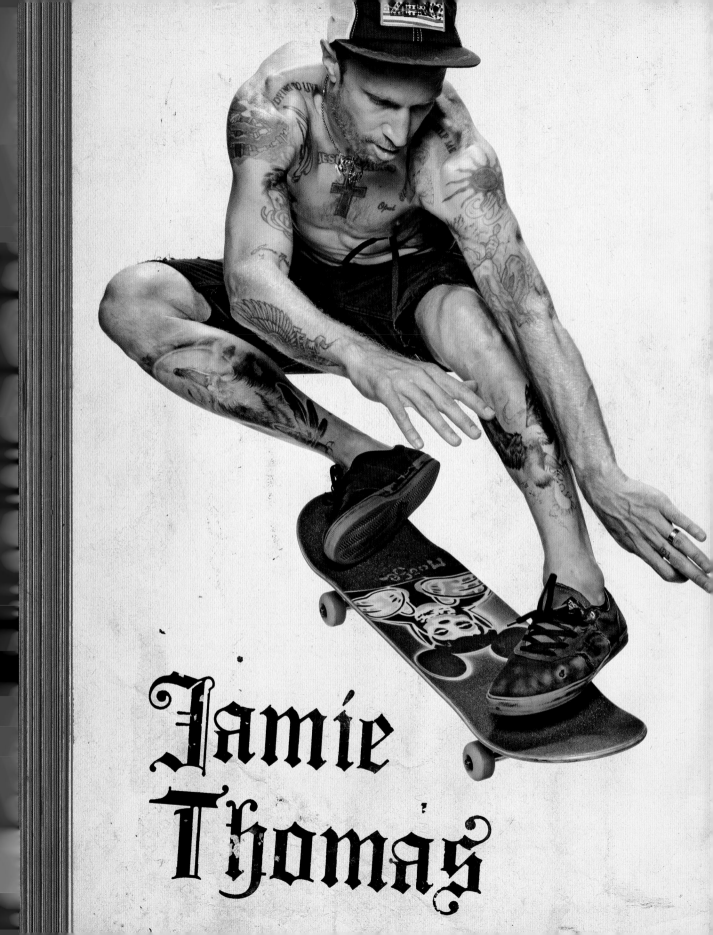

Jamie Thomas

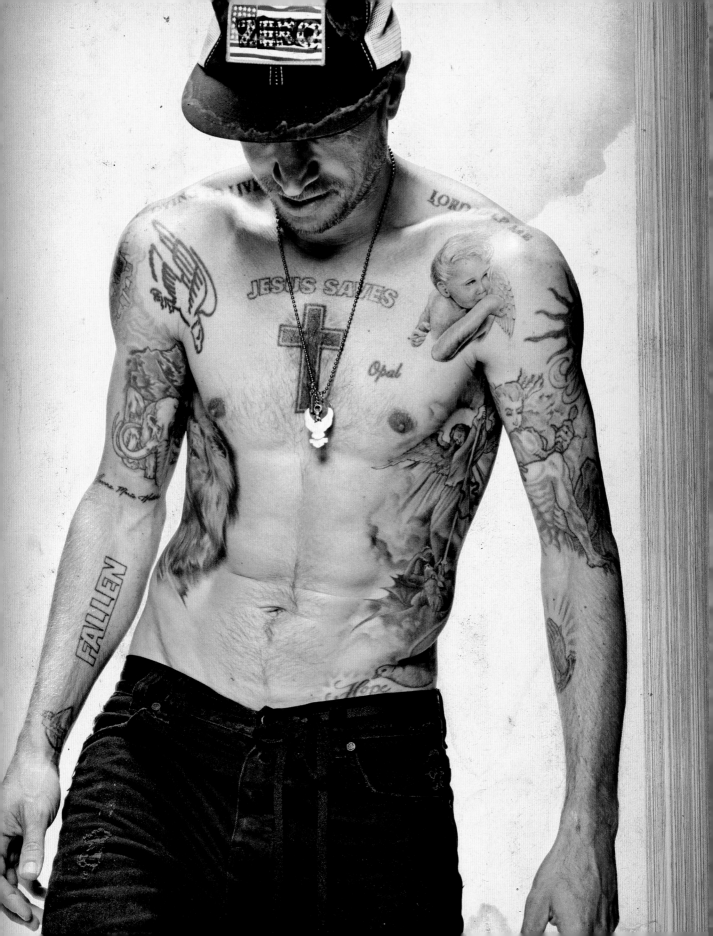

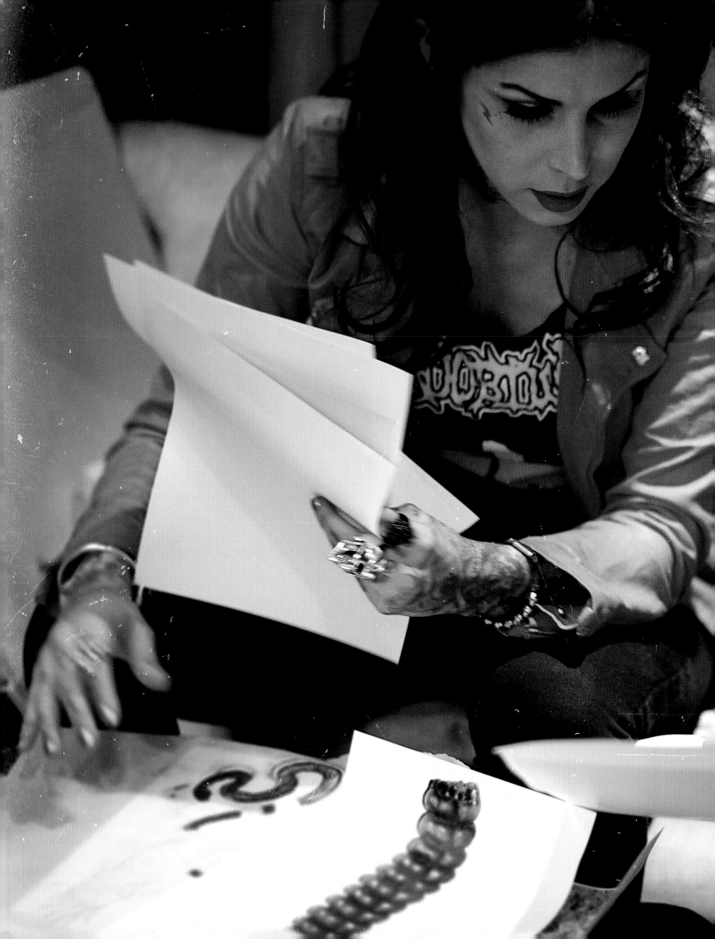

"Wisdom is learning from your mistakes and embracing change."

—JAMIE THOMAS

Always well-prepared for his sessions, Jamie showed up with neatly organized files of references for his howling wolf tattoo—and a huge gash on his leg from skateboarding.

As painful as I'm sure the first session of working on the wolf became for Jamie, I was enjoying getting lost in the many different textures of the piece. Following the flow of the fur, down into the shiny metallic texture of the bullet on the centerpiece that nicely framed the tattoo, and then advancing to the starry black sky that set the background for the entire piece, was completely absorbing. As subtle as the white highlights of a tattoo always tend to be, they were essential to Jamie's tattoo, creating depth, detailed texture, and shine.

I've known Jamie for quite some time now. We first met through mutual pro-skater friends of ours and then established a more solid friendship with every tattoo session. Jamie motivates me; he's constantly coming up with new projects and business ideas. Not only does he have amazing ideas, but he executes them with a high degree of success. He's a prime example of if you can dream it, you can do it.

Jamie became a professional skateboarder in 1992. In 1996, he started a small clothing company, which evolved into the highly respected Zero Skateboards that he co-owns today. In 2000, after recognizing that there was a shortage of footwear brands for skateboarding, he launched Jamie's Fallen Footwear, which was a hit within the skateboard community and then a mainstream favorite. This list of what he's achieved is pretty impressive because he's branched out into everything from distribution companies to filming and editing groundbreaking skateboarding videos to creating YouTube channels. In 2006, he won the regional Entrepreneur of the Year award from Ernst and Young.

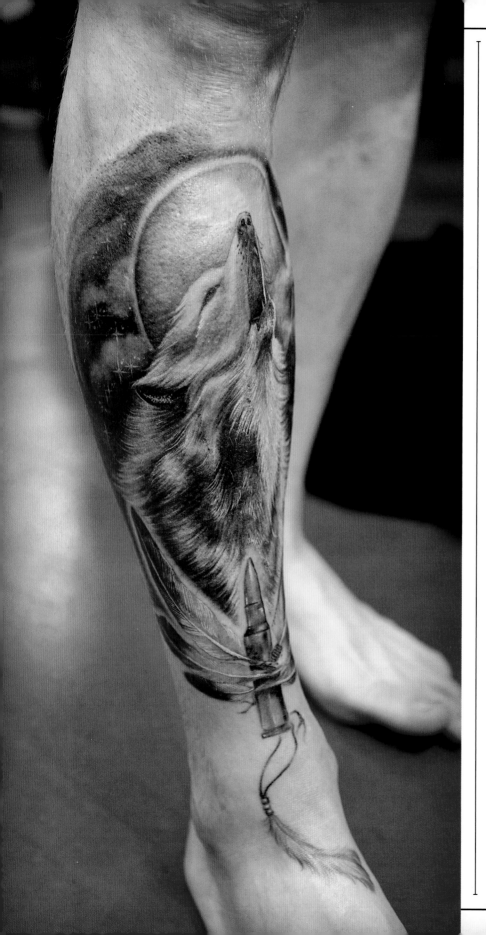

Today, Jamie still sets skateboarding standards and is a leader in the skateboarding world.

With all of these creative and highly productive outlets stacking up, Jamie is acutely aware of his ability to inspire and advise up-and-coming skateboarders. The example he sets is incredibly motivating, but his great humility would never allow him to say that out loud. He doesn't have to; it's clear nonetheless.

Tattooing Jamie always gives me the chance to pick his brain, to learn something new. I could write an entire book based solely on everything that I've learned from him. We talk about everything, but a subject that always arises is balance. Both of us have struggled to find a healthy balance between doing all the things that we want to do and all the things we think need to be done.

As his life has shifted from skateboarder to entrepreneur, from single man to married father, He had to learn how to evolve. When he was young, it was easy to spend his time focused on his boarding and his developing businesses. Now, he has to prioritize his family as well, and while nobody is perfect, he has managed to embrace the changes, and be a great dad as well as an industry sharpshooter.

Judging by Jamie's accomplishments, one could easily say that he is a "great success." The most beautiful thing about it is that if you ask Jamie what he considers to have been his biggest achievement, he points to his marriage. Having celebrated more than fifteen years with his wife, creating a healthy and happy environment for their three kids: those are the triumphs he holds most dear.

It can be tough at times for driven people, who are fueled by passion, to remember to remain conscious of the needs of the people in their lives, but staying connected to what truly is important is key—Jamie taught me that. ✛

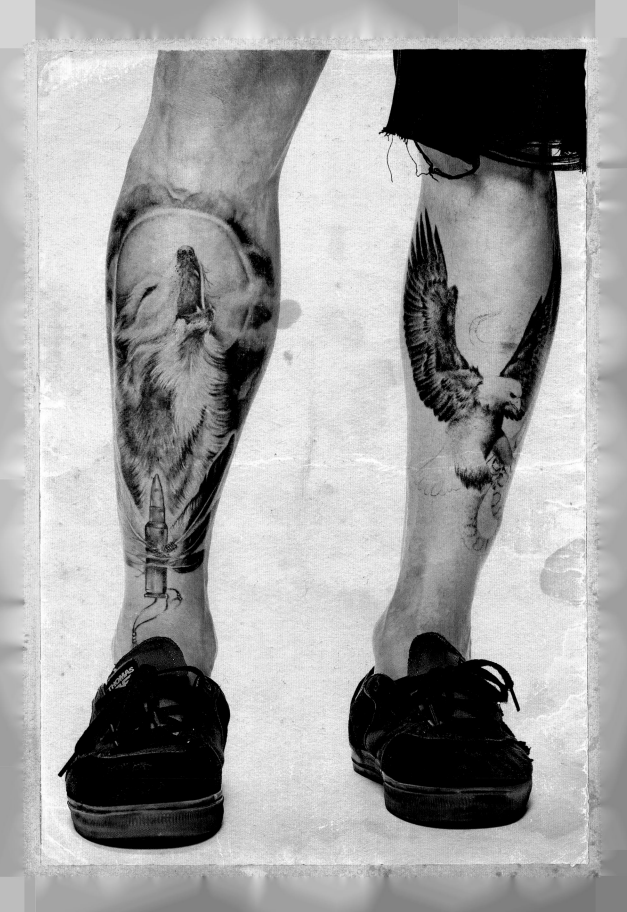

2012

"Ultimately, it is the desire, not the desired, that we love."
—Friedrich Nietzsche, *Beyond Good and Evil*, 1886

he silver plane hurtled over Newfoundland, over the Labrador Sea. Someone had told me I might see the northern lights as I flew east and north, but I wouldn't have noticed because I was too deep in writing the letter I had already mentally composed long before I decided to make this trip to see him over New Year's Day. I didn't have to edit myself this time. I knew exactly what the letter would say.

I reread the note to myself only once before sealing the envelope. Then I drew out the first letter of his name in pencil on the front. What a beautiful letter it was, probably my favorite out of the entire alphabet. A letter I was so used to writing myself. With ease the swirls and curves of each arch seemed to flow from my heart, to my mind's eye, down in and through my arms to my hands, releasing themselves onto the pale ivory paper envelope.

My plane landed soon after.

I had missed this country, and I had missed him, too. I wondered how time had treated him, for it had been a few years since I had last seen him. I wondered if I still had the ability to quiet his heart when he was feeling manic. He always said I had a way of doing that when I was near. And I wondered if he even needed me in that way anymore.

When we met up, he looked just as beautiful as the day we saw each other for the first time, almost ten years before. And as if no time had passed, we started up right where we left off—hours flew by in the comfort of each other's presence. Talking. Catching up.

He asked if I was getting sleepy, and my attempt at concealing the tiredness was transparent. I looked at the clock; maybe it was the jet lag or the clock hands pointing to midnight, but I knew it was time to say good-bye. Reluctantly, we both stood up and tried our best to part ways.

As good as it felt to be near him again, I gave him the letter I had written letting him know that I was letting the notion of us go. He took the sealed envelope, and then I watched him walk away for what I assumed would be the last time.

My heart didn't belong locked up in a tower across the ocean from my home. It belonged in my chest, beating, living, feeling, sometimes hurting, but always loving. I deserved to be free, and understanding and needing that more than a dream, I was finally able to let him go.

"The purpose of life is to discover your gift. The work of life is to develop it. The meaning of life is to give your gift away."

—David Viscott, FINDING YOUR STRENGTH IN DIFFICULT TIMES, 1993

There's a profound joy that comes from being selfless.

A couple of years back, my sister shared something with me that has remained with me to this day. She had just come back from a lecture on being of service to others. She glowed with excitement as she told me about the parts of the lecture that resonated with her, and, honestly, I hadn't seen her happy this way in a long time.

She told me that the speaker urged everyone to consciously engage in three random acts of kindness per day. Some of the acts could be small, like going out of your way to help an elderly person carry groceries across a street or giving up your parking spot in a busy lot. Other acts could be greater, of course, like donating belongings of high value to help a charitable cause, or volunteering to helping those in need.

He described how these efforts would spark a change in your life. You would gradually start to notice

PRACTICING ALTRUISM IS ONE OF THE GREATEST EXCHANGES OF ENERGY.

how in each day and in whichever direction you'd look, there'd be opportunities to help others. Making a habit out of searching for these opportunities to be of service was simply a way to become aware of how much power we have to affect others in a positive way.

The only catch to this practice, Karoline told me, was that once you complete the three random acts of kindness each day, you can't tell anyone about it. You keep your good deeds to yourself, and actually leave them behind in the moment that they took place. You don't keep tabs or feed your ego by telling yourself how awesome you are. You simply help others, and in doing that, you feel the joy of simple giving, and that alone is your reward.

I understood why my sister was so excited, because the minute she told me about what she had learned, all I could see were opportunities to help people around me.

Sometimes, just a smile was enough. I found myself asking what I could do for my friends in time of need, instead of judging them or the situation. This practice made me a better listener, friend, neighbor, and boss. Without disclosing examples of what acts I had done, I noticed something immediately. I recognized the power I have to bring my presence, my positivity, my peace, and my stillness into the worst of scenarios. The joy I felt as a result of that had nothing to do with feeling powerful or being acknowledged. The joy came from giving the gift of love to another person.

Practicing altruism is one of the greatest exchanges of energy. Helping others without any expectation and without gain is just as much a gift to yourself as it is to the person you give to.

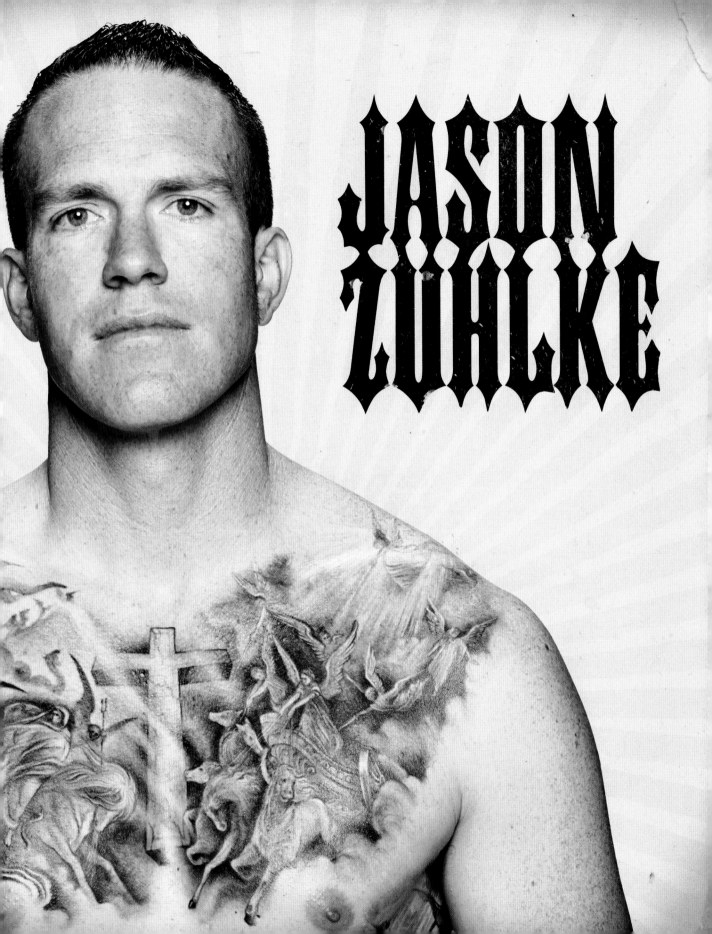

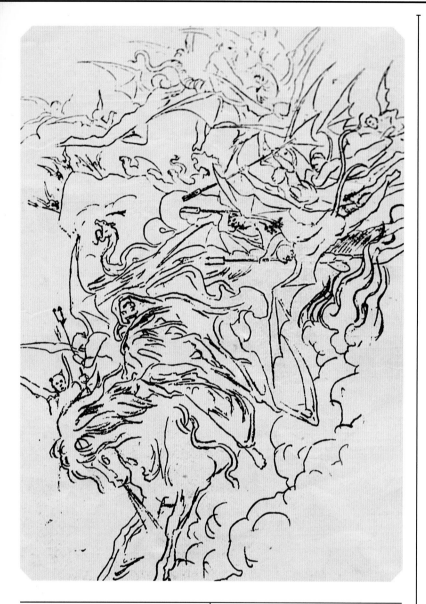

or try to etch a psychological map of where they are."

Admittedly, Jason has had to work at removing biases and presuppositions at times. To begin with, though, he tries to mentally prepare himself to being open to serving others. To serve others in an altruistic fashion means that the giving is done without expectation or reciprocation.

"I don't give a shit about the 'thank you' card," he once said to me.

On another level, Jason's job also lends itself to selfless service to those he works with. From what he tells me, Jason is surrounded by men and women who have a heart for this job and as a supervisor, he is able to coach and mentor them. He inspires his team to greatness through what he refers to as servant leadership. His approach to leadership is all about teamwork, mutual respect, and a willingness to serve each other as a unit, and I can totally relate to that in terms of my comparatively small team at High Voltage. When I hear Jason talk about how happy it makes him to be able to inspire people through that type of leadership, I want to work even harder to be like that with my crew.

Jason's vision for the entire composition for this tattoo on his chest was simple: the fight between good and evil, which makes perfect sense, given his line of work. The piece was his second Gustave Doré-inspired tattoo, and we spent well over ten hours defining every detail. The tattoo starts at one shoulder, stretching across each pec and clavicle, down to his sternum, then over to his other shoulder. It was a huge project, but we chipped away at it just like we had done on his prior piece on his rib, which took thirteen hours to do.

For this tattoo, rays of light pour behind and through clouds in the distance on Jason's left side, lighting a pathway filled with the radiance of white angels, some with open wings, swooping down, and others taking

F or Jason, selflessness is a daily walk in humility, openness, self-reflection, prayer, and active listening.

Being a sergeant for the Los Angeles County Police Department, Jason finds himself in service to the public day in and day out. On a constant basis, his job requires him to be a witness to the best and the worst the human experience has to offer. One moment Jason could be finding a lost child, while the next he could be handling a murder. Regardless, there is always an opportunity to graciously serve another person in a time when he or she needs it the most.

This may sound cheesy, but I honestly believe the world is a better place because of Jason. When Jason shares with me some of his experiences out on the streets, I can't help but admire the way he handles things—and I always learn something. He always figures out how he can meet people where they are at their time of need. In other words, you have to see the need in order to meet the need. He once told me, "The trick is not to merely categorize a person

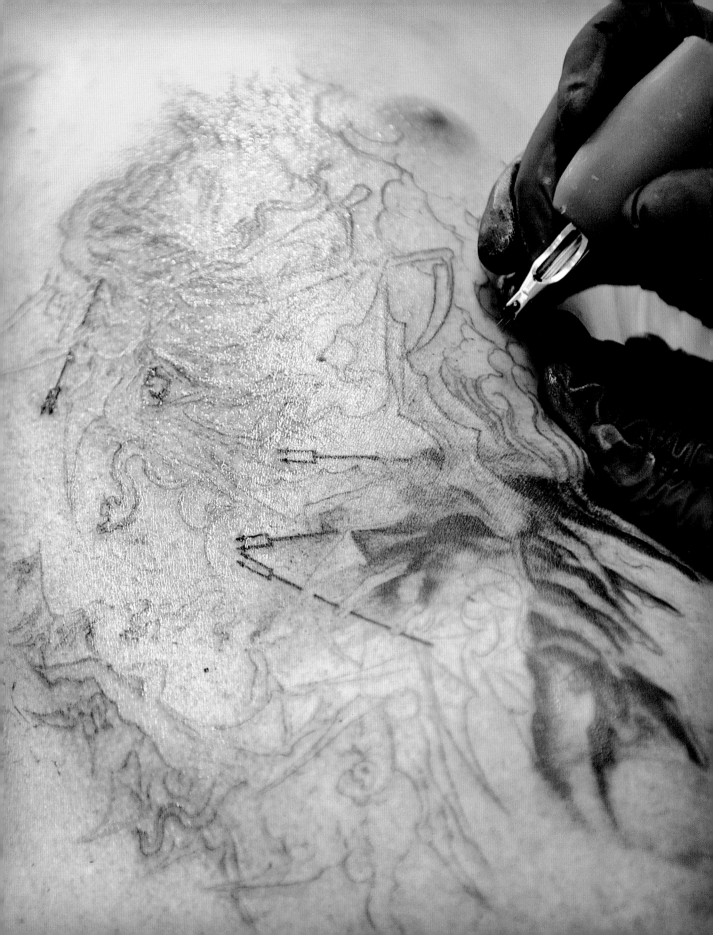

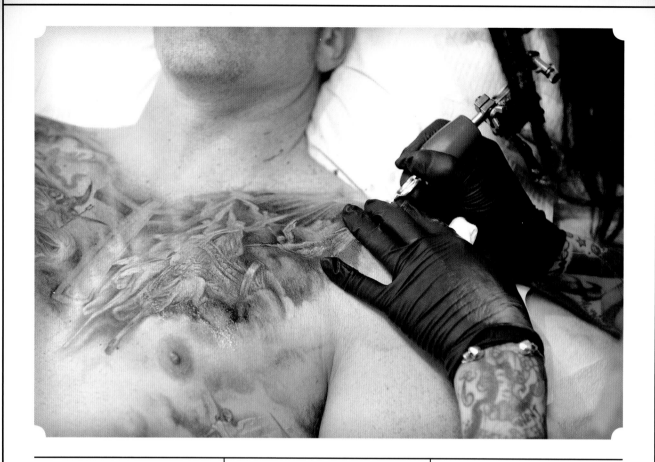

"**Where do I need to be to discover the beauty of another soul so that I might care for them selflessly without expectation?**"

—JASON ZUHLKE

the reins of golden chariots, all with swords extended, ready for battle.

On Jason's right side, the doom and gloom launches from a similar starting point on the body as the left side, and flows down, forming a stream of demonic creatures. Bat wings and scaled tails weave throughout the storm of fallen angels. The focal point of this darker side resembles Father Time, complete with hooded cloak and sickle.

I wanted to give the crucifix in the center of Jason's chest as much depth and texture as possible, so that when you look at the piece in its entirety, regardless of the point at which you start, your gaze will always end there. Negative space and soft, smoky shading give the illusion that the clouds on both sides part and dissipate as the cross emerges forward. And if you look really closely, the subtle texture of cracks gives the feel of stone.

After years of getting to know Jason through our long tattoo sessions, he's become a friend. He's told me some of the most gut-wrenching, unbelievable, and motivating stories about his work, and I'm convinced no one is better cut out for the job.

I recently asked Jason what he gets out of being on the police force—even though I already had an idea of what his answer might be. He told me, "If I had to assign a word to the meaning of 'being of service to others,' that word would be 'joy.' There's nothing more intrinsically rewarding for me than knowing I have been a light in someone's life. It is God-inspired, God-honoring, and spiritually fulfilling to know that I served someone today. And, that service may not always be through an act; it could simply come by way of a great conversation, a smile, or a symbol." ☩

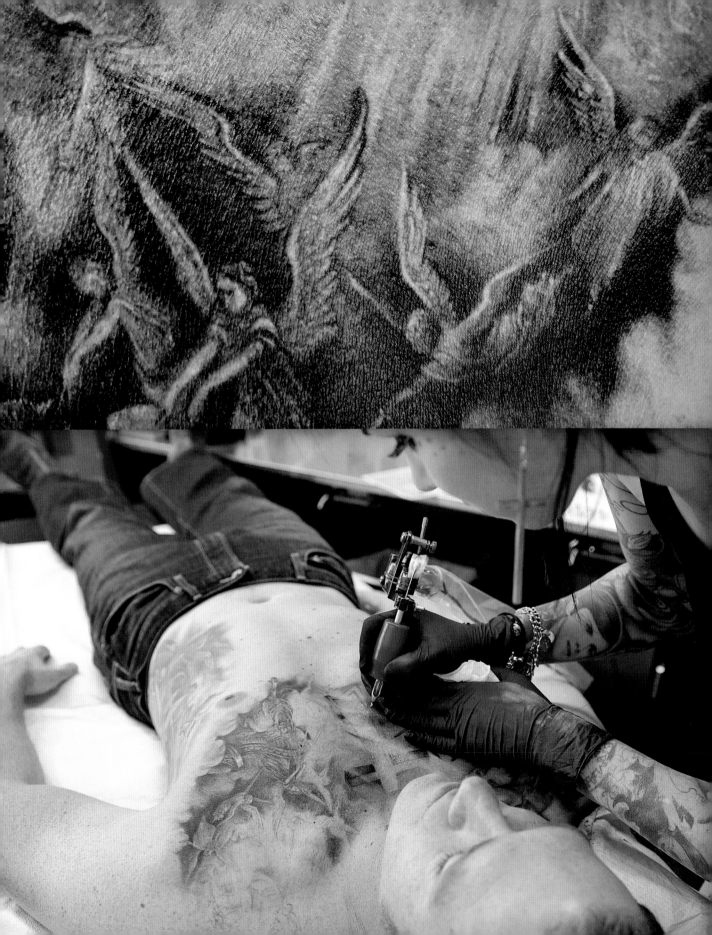

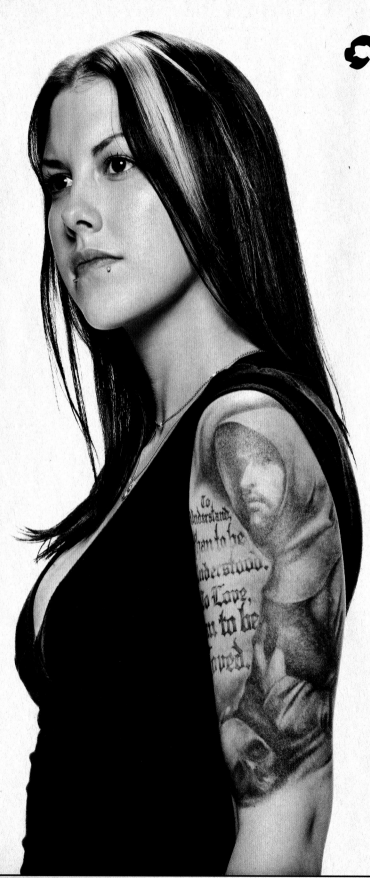

Kristen Hyde

The beauty and meaning of words can be so powerful, and this is the reason poetry, song lyrics, and famous quotes have always been a huge part of tattoo concepts. The words I have chosen to have tattooed on myself have significance for the most part. As beautifully rendered as some of the lettering may be, the primary reason I chose to mark my body with these words isn't for others to read. They are affirmations and reminders to myself.

For example, the word "Aware" is one tattoo that I see more than any other. I had it tattooed on the top of my hand to constantly remind myself that in times where I'm faced with adversity, instead of reacting emotionally I should step back, take a breath, and be aware of what is really happening. Most of the time, a reaction isn't needed. Most of the time, if I take a moment to reflect and really look at what I think the problems at hand are, I realize that things are fine.

The words Kristen chose to incorporate into her Saint Francis of Assisi tattoo, were taken from one of

his prayers: "To understand, than to be understood. To love, than to be loved."

When she heard this prayer for the first time, these twelve words struck a chord deep within Kristen, in turn sparking a groundbreaking realization. Kristen had been referring to herself as "the misunderstood girl," but after hearing these words, she realized that life wasn't about expecting others to understand you, but more about being an understanding and giving person. Expecting people to love her, when she herself wasn't willing to give love in return, made it impossible fo r her to succeed in her friendships and intimate relationships.

For Kristen, the prayer symbolizes selflessness and humility. It inspired her to reassess some of the ways she had been living her life and treating those around her.

"This tattoo is a constant reminder to continuously strive to be the best version of myself—to treat others the way I would like to be treated," she told me.

I knew that it was going to be important for Kristen to be able to see this tattoo on a daily basis, so although Saint Francis would remain the central focus of the tattoo to anyone who would look at it if they were standing near her, I figured if I somehow managed to place the words toward the front of her arm, centering them on the front of her bicep, the words would be the main focus when she looked down.

Instead of a traditional approach to script, I based the lettering on an Old English–style font. The idea was to give the words texture so it would appear as if they had been etched into the space behind Saint Francis.

I saw Kristen after the tattoo healed, and I was so happy when she told that not only has it served its purpose for her personally over and over again, but it has also touched others who have come across it, too. ✙

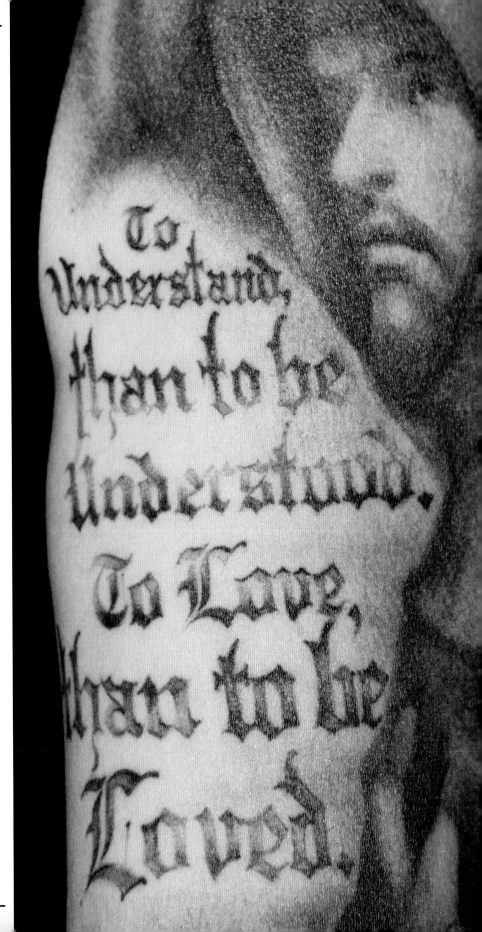

Ashton
Williams

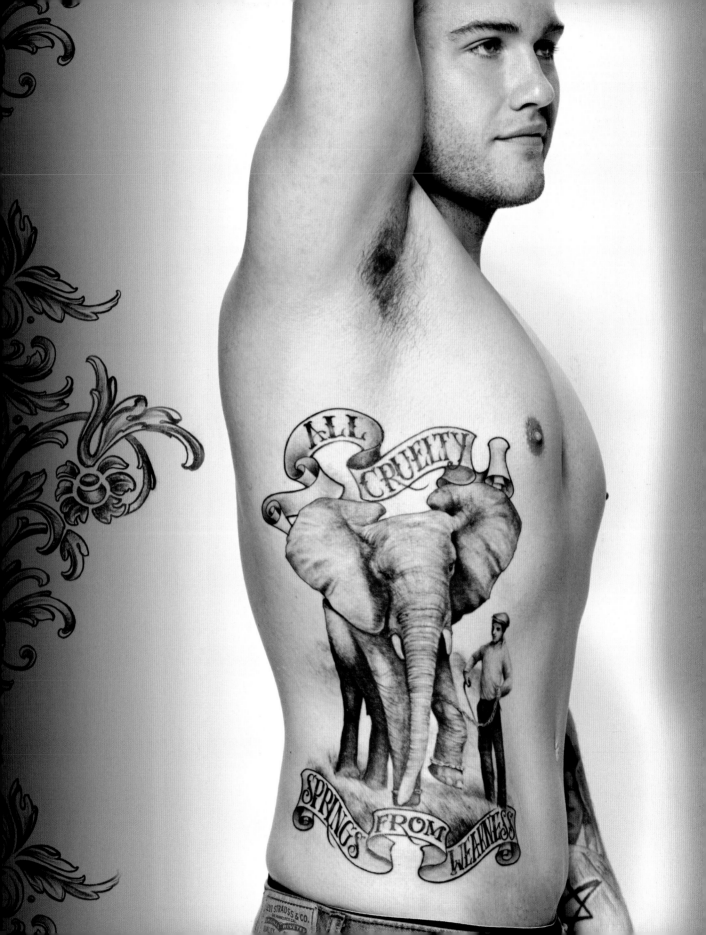

Ashton was raised on a farm in Virginia, and animals—both domesticated and wild—have always been a big part of his life. He's always had a real interest in exotic animals and has had many, including a coatimundi named Bug. At fifteen, he became a vegetarian because, as he said, "I didn't want any animal to suffer for something as meaningless as my food or sense of taste." Seven years later, he watched the documentary *Earthlings*, and it changed his whole perspective on the dairy and meat industry—so much so that he decided to become vegan.

I've tattooed Ashton five times over the past few years. No matter how busy we are, or how far away from each other we've been, we always manage to come together for a tattoo. Ashton and I share a deep love of and compassion for animals, and somehow our conversations always lead back to them. So when Ashton wanted a portrait of Jumbo, one of the first circus elephants, I thought it was a great way for him to demonstrate his passion for animals and animal activism. He had the idea of putting a quote around the portrait, choosing "All cruelty springs from weakness" because it not only speaks to Jumbo's fate and animal activism, but is also a simple truth.

I will never understand how anyone could be cruel to an animal.

After Valentine died, I did get another hairless cat. I named him Piaf. In the morning, I wake up to the sight of him curled up into the tiniest ball of hairless skin imaginable on my bed. Shortly after I open my eyes, he does too, and we stare at each other, the silence punctuated by slow and heavy blinks. I'm not really one of those cat people who talks a lot to their cat—that's not how we interact. Piaf's not one to meow a ton, so we're perfect for each other.

I named Piaf after the late French singer, Edith Piaf. Edith was abandoned by her parents at a very early age, just like my cat. Out of all the little kittens in the litter, Piaf was the runt, and his mother refused to let him feed from her during those first vital stages of his life. Being bottle-fed by humans made him attach so much more to people than to his own species.

Piaf is a French word that translates to "little sparrow." Edith herself was given that same stage name because of how small and frail she was, with many childhood health problems. As tiny as a little blackbird, Piaf's below-average-size frame and giant ears endeared him to me. He took a liking to me straightaway, too, and comfortably nestled into my arms like a small noodle.

A photograph of my hairless Piaf is by no means "cute" when compared to other fluffy "normal" kittens. I can never understand why anyone would

feel inclined to say this tiny gift from nature is hideous, gross, or disgusting. But they do. I have yet to see one photo that I post on Twitter go without half of the responses casting this little being in a critical light. I used to get upset when I'd read through the comments, sometimes even responding to the ignorant feedback by trying to explain all of the above in fewer than one hundred forty characters. But now, I need only to remember those still and quiet moments in bed with Piaf, where I am never distracted by any noise outside those four walls of my bedroom.

To me, Piaf's beauty and sweetness are so transparent, and incomparable to any other cat. It never fails that when someone who has a negative opinion about this particular breed of cat meets little Piaf—they immediately fall in love.

On those mornings when I wake up to Piaf's wrinkly face and velvety warm body, I can only see love. He does not judge or criticize or resent. He doesn't hold a grudge. He doesn't live in his mind and fixate on the past. All he knows is how to love and be loved in return. He just is.

Much like children, animals can be some of the greatest teachers if we just observe their natural behavior. Most people are familiar with Darwin's idea of "survival of the fittest." But there is another scientific concept: "survival of the nicest." Altruism in animals is well documented, from dogs adopting orphaned cats to a bonobo who helped a starling learn to fly. And many pet owners have stories about their animals staying close to comfort them when they were ill, or even saving their lives.

Out of the many tattoos I have done on Ashton, this one has been by far the most challenging to take on, but it has also made me feel the luckiest to be a part of considering how much I know it means to him. ✛

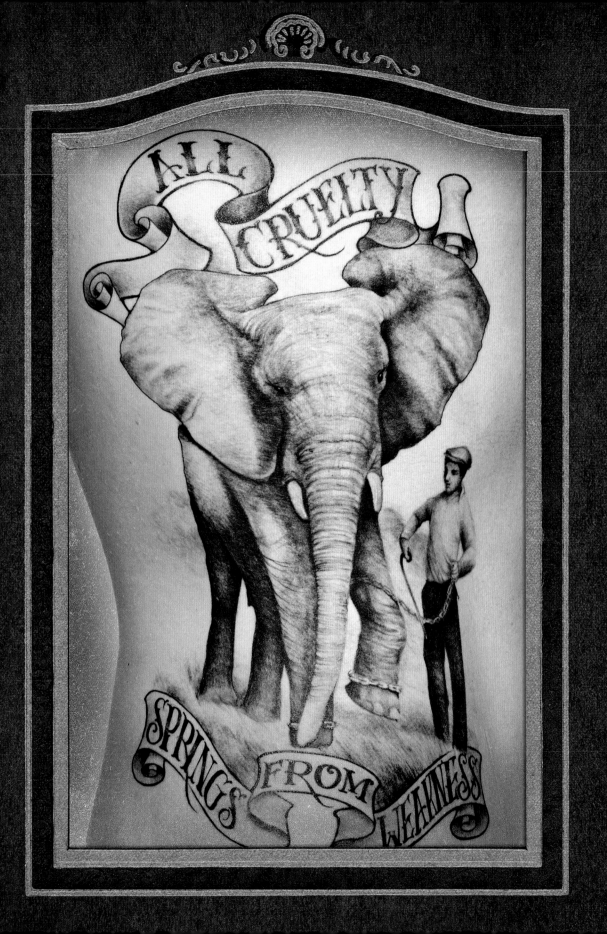

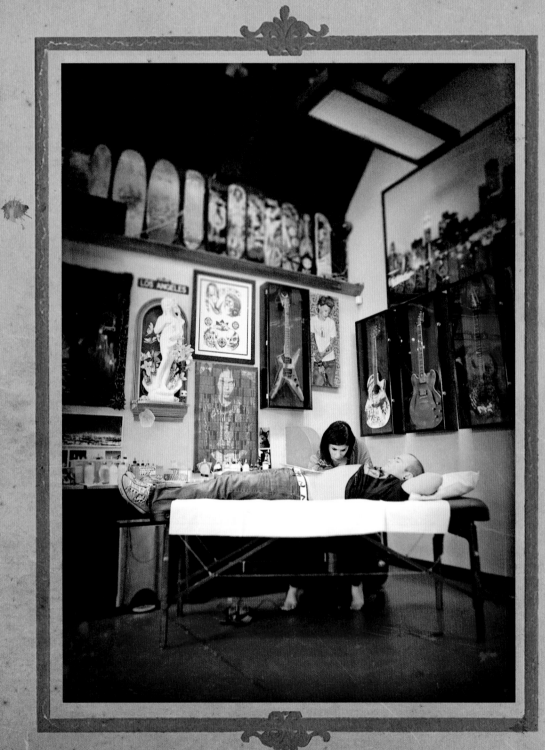

Afterword

There were only a few minutes before the red velvet curtains would open, and singing out loud in front of people would become something more than an image in my mind.

I looked down at the table of piano keys in front of me. I replayed the simple four-chord progression that I had stayed up practicing until two A.M. the night before. I'd hammered it into my memory with the hope that tonight, right here, and right now, I wouldn't somehow forget it.

Danny had torn pieces of Scotch tape and placed them on the key notes to hit, just in case I lost my place. As he stuck the tape on the black and white keys, he said, "Don't worry. You should have seen my keyboard when I played shows. There were scribbles and marks all over the damned thing."

I looked at the crude shapes he had drawn: two stars, a cross, and a heart. Danny believes in me. If ever there was anyone on this planet who I'd want to share this groundbreaking moment with, it would be him.

I looked up from the keyboard to see Danny and Wes sitting like such the perfect gentlemen. Their neatly

combed hair, tailored suits, and dapper smiles would have never given away the fact that less than twenty-four hours ago, the three of us were all sitting in Danny's living room desperately trying to learn this song at the last minute.

Somehow, we pulled it together, though. And somehow, I pulled myself together, even though I kept thinking I should have made more time to learn the music. Practiced more. Even if I had had just one more day to run through the song, I could feel a little bit more confident, a little more sure of myself. Sound check had been so rushed, and I really didn't know what I was doing, or what I would sound like. This was my first time. This was

it. This time, I couldn't talk my way out of singing in front of Linda at her studio. This time, there was no more time to buy. The mental countdown had officially begun, and the audience waited.

I took the three deep breaths I usually take in times like these.

This wasn't about proving myself to the world, or showing off the thing I could do. Beyond those curtains were just other people, people who were just as scared of things in this world too. Tonight had nothing to do with this performance. Tonight was about me not running away or using the past or the future as an excuse to hide. Tonight was about loving myself, not allowing myself to be my own worst enemy, about starting to believe that I am good enough.

The time was here, and on this cold stage, the red curtains were rising. Things were about to become very real. Hello, vulnerable.

But that's what risks are. Risks aren't the easy choices: red nail polish or blue? There's nothing risky about nail polish, no matter how pretty it is. One swipe of remover and you're right back where you started, no harm, no foul. But risk leads to permanent changes, like tattoos that cover the entirety of someone's chest or back or arms or legs. Risk changes us forever. We climb up on the bench to get tattooed, or on the surf board, or on the stage, and by taking those chances, we evolve.

The people who have come through my shop doors are risk takers, whether or not their tattoos are microscopic compared to all of the large-scale tattoos I've done. They inspire me to push boundaries in my own life as I see them doing in their own. Some of them jump off buildings because they feel the need to or start skateboarding companies. Some wake up every day and work with numbers and letters in sky-high buildings downtown, while others work as police officers on the streets below. Some courageously transition from male to female when that's what feels right, no matter what the neighbors say. Some even leave behind their old lives and start new ones. They are the risk takers, change makers, doers, and daredevils. They are creators of their own realities.

Well, this book isn't for them. It's for people like me, who sometimes forget how it feels to let themselves be free.

By the time it really hit me that this was it, our dark hideaway behind the curtains had quickly transformed into a light-filled stage, and I was already following Danny's lead as he counted us into the song.

One. Two. Three.

I was singing.

No words could ever fully describe my love for music really. Linda once told me, "Just like you have honored and been good to it, music will be good to you, too." And yeah, there were moments of self-doubt on stage, wondering whether I was doing the music justice. But the only thing I could really do was try my best.

Everything was said and sung. Our song was over, and still too shy, I found no courage to look into the crowd of clapping people in front of us. Scrambling to find a way to show my gratitude to Danny and Wes, I blew a kiss in their direction.

"Thank you."

I was thankful to my two friends who helped make tonight happen—and to Linda for inviting me to sing on her stage that night. But as the curtains closed, muting the clapping and woohoos on the other side, I felt grateful for the heartache of the unrequited love and the accompanying anguish and longing that inspired me to sing to begin with. If it took going through that to get to this moment, it was well worth it.

At that moment, with my heart filled to the brim with appreciation for this life, all I could say to myself was, "Right here, right now, I am free."

K. J. Druckenberg

Acknowledgements

Thanking you from the bottom of my heart......

- Elizabeth Viscott Sullivan, for once again making this all happen.

- Tattooing, for saving me from myself.

- My High Voltage Tattoo Crew and Wonderland Gallery Family, for not only being one of my greatest sources of inspiration, but for being the family I always wanted. •ego sum domus•

- George Falcon, for teaching me that right here, right now, I am free.

- Danny Lohner, for everything. You are my best friend.

- Wes Borland, for #sexypianotalk.

- My Father, por siempre apollar me y por todo lo que me enseñas todos los días.

- Linda Perry, for your words, your songs, your beauty, and your love.

- Ken Tamplin, for teaching me how to sing, but more important, for your prayers.

• **Vampira**, for being the closest thing to a hero that I've ever had. I wish so badly I could have known you in this lifetime and on this planet, Maila Nurmi.

• **Ryan Adams**, for inspiring true, noble love.

• **Andrew "Stu" Stuart**, for capturing this moment in time with that magical camera of yours.

• **Sandra Bark**, for going big when all we ever wanted was to go home.

• **V.**, no number of songs, drawings, or words could ever be enough.

———————— // ————————

And a special thank-you to the following:

Billie Joe Armstrong, The Art of Elysium, Allison Burns, Jacob Covey, Sandra DiAmante, Patrick Hoelcke, Jyrki 69, Kent (my favorite band of all time), AnnaRose Kern, Dina LaPolt and the gang, Brad Lyon, Bam Margera, Stefan Orn, Piaf, Felix Rodriguez, Sephora, sobriety, Jeffree Star, Alec Gulkin, Tony and Melissa Jornay, transcendental meditation, and Lynne Yeamans.

My heartfelt thanks to my fans, who inspire me ~~everyday~~

———————— // ————————

Bibliography

Biddulph, Desmond. *1,001 Pearls of Buddhist Wisdom*. San Francisco: Chronicle Books, 2007.

Dali by Dali. Dali, Salvador. New York: Harry N. Abrams, Inc., 1970.

Emerson, Ralph Waldo. *The Conduct of Life*. Boston: Ticknor & Fields, 1860.

Epictetus. Goodreads. www.goodreads.com/author/quotes/13852. Epictetus. Accessed June 25, 2012.

Gottlieb, Sidney, ed. *Alfred Hitchcock: Interviews*. Jackson, Miss.: University Press of Mississippi, 2003.

Lao-tzu. (Hua-Ching Ni, trans.) *The Complete Sayings of Lao-tzu*. Los Angeles: Sevenstar Communications, 1995.

Marcus Aurelius, *Meditations*. New York: Penguin Classics, 2006.

Nietszche, Friedrich. *Beyond Good and Evil: Prelude to a Philosophy of the Future*. Edited by William Kaufman. Translated by Helen Zimmerman. New York: Dover Publications, 1997.

Poe, Edgar Allan. "A Dream Within a Dream," First published in *A Flag of Our Union*. Boston: 1849.

Sitwell, Edith. www.economist.com/node/18175321. Accessed June 1, 2012.

Tharp, Twyla. *The Creative Habit*. New York: Simon & Schuster, 2003.

Thoreau, Henry David. *Walden*. Boston: Ticknor & Fields, 1854.

Tolle, Eckhart. *A New Earth: Awakening to Your Life's Purpose*. New York: Dutton, 2005.

Viscott, David. *Finding Your Strength in Difficult Times*. Chicago: Contemporary Books, 1993.

Photography Credits

Go Big or Go Home

HarperCollins books may be purchased for educational,
business, or sales promotional use. For information please
write: Special Markets Department, HarperCollins*Publishers*,
10 East 53rd Street, New York, NY 10022.

First published in 2013 by:
Harper Design
An *Imprint of* HarperCollins*Publishers*
10 East 53rd Street
New York, NY 10022
Tel: (212) 207-7000
Fax: (212) 207-7654
harperdesign@harpercollins.com
www.harpercollins.com

Distributed throughout the world by:
HarperCollins*Publishers*
10 East 53rd Street
New York, NY 10022
Fax: (212) 207-7654

Library of Congress Control Number: 2011931362

ISBN 978-0-06-210813-5

Book design by Jacob Covey/Unflown

Printed in the United States of America